IMAGES
of America

AROUND TERLINGUA

To Herminia

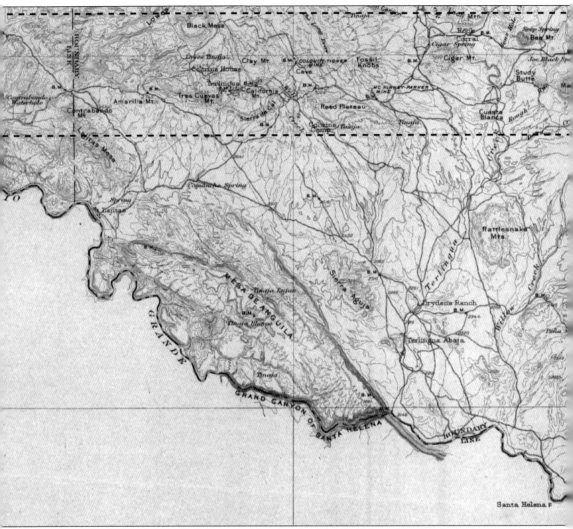

The core area covered in this book extends from Lajitas on the Rio Grande (at left) to Study Butte (at extreme right). The Terlingua Mining District occupies the upper portion of this map. The community discussed herein encompasses the greater part of this 1904 map. (Courtesy of US Geological Survey.)

ON THE COVER: The furnaces at quicksilver mines throughout the Terlingua Mining District required large quantities of wood for fuel. Wood was cut and hauled from as far away as the Chisos Mountains, a distance of 25 miles. A lack of roads from the Chisos to the mines prevented the mountain woodland from being clear cut. Most wood came from the banks of the Rio Grande and its major tributaries, primarily Terlingua Creek. Wood was hauled in Studebaker wagons that were designed to carry 7,000-pound loads but commonly carried almost twice that amount. During peak years of operation, the Chisos Mine contracted eight haulers. Felix Valenzuela, shown in this image, had four wagons and maintained a herd of between 30 and 40 mules. (Photograph by Glenn Burgess, courtesy of Jack Burgess.)

IMAGES
of America

AROUND TERLINGUA

Thomas C. Alex and Robert E. Wirt

ARCADIA
PUBLISHING

Published by Arcadia Publishing
Charleston, South Carolina

Printed in the United States of America

Library of Congress Control Number: 2014950705

For all general information, please contact Arcadia Publishing:
Telephone 843-853-2070
Fax 843-853-0044
E-mail sales@arcadiapublishing.com
For customer service and orders:
Toll-Free 1-888-313-2665

Visit us on the Internet at www.arcadiapublishing.com

In dedication to Robert Wirt. His passing on January 12, 2013, was a shock to many and a loss to the heritage of Terlingua.

CONTENTS

ACKNOWLEDGMENTS

Sources for many of the photographs contained herein include the Archives of the Big Bend and Museum of the Big Bend at Sul Ross State University in Alpine, Texas; Marfa and Presidio County Museum and Marfa Public Library in Marfa, Texas; and the National Park Service, Big Bend National Park. Very special thanks go to the families who not only have donated photographs but also have shared their most intimate family histories and related their family stories. We are most grateful to Louisa Franco Madrid, Antonio Franco, Genoveva Ramírez Rodríguez, Celestina Valenzuela, Juan Manuel Casas, and Maria Zamarrón Bermúdez for these contributions. Special appreciation goes to Jack Burgess for many of the mining-related images and to Rush Warren for access to some of these mining sites.

Also, the last-minute and short-deadline contributions by several need to be mentioned here. For their contributions to the chili cook-off segment, thanks go to Melanie Levin, Kathleen Tolbert Ryan, and Steve Tremayne of the Frank X. Tolbert–Wick Fowler Chili Cook-off and Kris Hudspeth and Jennifer Sherfield of the Chili Appreciation Society International Inc. cookoff. Louisa Franco Madrid and Antonio Franco stood by me until the very last day of editing. Juan Manuel Casas also contributed significantly at that point. Carolyn and Jim Burr, Marcos Paredez, Beth García, Mike Long, and Crystal Marks were also good friends and contributors. Many others, too many to mention, are credited beneath their photographs.

Scarlett Wirt deserves a special mention for working patiently with everyone after co-author Bob Wirt's passing and for donating all of Bob's research data to the cause. Thank you especially, Scarlett, and to Bob, wherever your soul resides, blessings and peace, my friend. We will do our best to continue your legacy.

The most gratitude cannot be adequately expressed, and it goes to my wife, Betty Alex, whose tolerance of my idiosyncrasies and moodiness during this process comes from her dedication and patience. Betty has lived in an unfinished house, stumbled over partially finished walkways, and allowed me the time and space to complete this tome. I am most grateful to this blessed woman. She is also my best critic and editor.

The remaining thanks go to all the people who made Terlingua what it once was and what it is today. Peace to all.

INTRODUCTION

The origin and derivation of the name Terlingua is obscure and lost to time. Various versions shown on old maps of the area indicate the place as Lates Lengua, Latis Lengua, Tarlinga, and Tres Lenguas, but the true origin is still debated. The name refers to the major tributary of the Rio Grande that flows for over 80 miles from central Brewster County to its confluence with the Rio Grande at the mouth of Santa Elena Canyon. Its waters have nourished cowboys and Indians, farmers and miners, and still support livestock and an amazing array of wildlife species.

Spanish soldiers and mission priests first entered the region in the 17th century, and Hispanic people began settling here in the late 18th century by establishing farming and ranching complexes. For a century, these newly arrived Europeans found themselves in competition with the indigenous American Indian people. Peaceful negotiations were difficult at times, but through perseverance, the Hispanic people found ways to live alongside their native neighbors. By the early 1800s, Spanish occupation of this territory consisted of small settlements called *rancherías* centered on ranching and farming. Most settlements were located at reliable springs or along permanent streams.

San Carlos, Chihuahua, located 12 miles south of the Rio Grande, was settled by American Indians long before the arrival of Europeans because of the abundant water there. It lies at the northern extreme of a larger indigenous culture area that occupied most of Chihuahua and extended into the Big Bend region. Around 1600 A.D., the Rio San Carlos was farmed by indigenous people related by language and culture to northern Chihuahua. These Concho speakers lived and farmed in permanent settlements along permanent watercourses, such as the Rio Conchos and the Rio Grande. In the 1700s, Apachean groups and southern Plains Indian groups pushed into the area at the same time that Spanish Europeans were attempting to take control of the territory. The indigenous people made pacts with these invaders to secure their own existence in this remote frontier. In many Spanish settlements like San Carlos, Europeans intermarried with native people, creating a rich intercultural mingling of old-world and new-world knowledge and traditions. This combined knowledge equipped people with unique practical wisdom, enabling their survival in an otherwise hostile environment. This wisdom forms a significant part of the heritage of today's Hispanic people.

Several small Hispanic farming settlements such as La Coyota and El Ojito appeared along the Rio Grande in the United States as early as the 1880s. Another small farming settlement about two miles north of the Rio Grande and along Terlingua Creek assumed the name Terlingua. In the late 1890s, prospectors discovered rich deposits of the mineral cinnabar in the area, and mines began to spring up to exploit the area and produce mercury, also called quicksilver. By the early 20th century, the Marfa and Mariposa, Colquitt-Tigner, Lone Star, Buena Suerte, Study Butte, and Chisos Mining Companies were busily extracting and producing quicksilver. When the Marfa and Mariposa Mining Company set up operations at California Hill around 1899, the company used the most well-known local name, "Terlingua," for the post office it

established in order to mail business correspondence. When Howard E. Perry carved his own chapter in mining history, the Terlingua post office was moved east to the Chisos Mine. The local Latinos commonly referred to the place as "Chisos" because of the strong impact the mine had on local economy and society. Under Perry's influence, Terlingua became synonymous with the Chisos Mine. The early farming settlement became referred to as Terlingua de Abajo, or lower Terlingua.

The Mexican people who already inhabited the region found employment at the mines and played roles in the successful development of the region. These industrious people were the backbone of the mining industry, and some of the families here today are descendants of the mine workers. Literally hundreds of Hispanic/Latino families contributed to the success of Terlingua as an extensive community of several thousand people, and this volume is inadequate to give appropriate credit. The stories told here are only representative of the many who substantially contributed to the development of present-day Terlingua.

Prior to the Mexican Revolution, many rural Mexicans lived under the *hacendado* system, essentially a serfdom in which a wealthy landowner took advantage of peasant workers to maintain large ranches. Many Mexican citizens fled to the United States to escape oppressive working conditions and the turmoil of the revolution. Many of the miners who worked at Terlingua came from the San Luis Potosí and Sierra Mojado mining regions in northern Mexico. The San Carlos crossing on the Rio Grande at Lajitas was a major path for Comanche warriors in the 19th century. The abundant water at San Carlos made it a major stop along the trail for travelers going either south or north, and many people coming to work in mines in the United States passed through San Carlos, Mexico, on their way north.

Mining has been a major theme in the history of the Big Bend region of west Texas, spanning the distance from the lead/silver mines in the Sierra del Carmen on the east side of Big Bend National Park to the silver mine at Shafter on the west. Quicksilver mining, in particular, played a major economic role and geographically spans the distance from Mariscal Mountain in Big Bend National Park west to the Contrabando Dome of Big Bend Ranch State Park, a distance of almost 50 miles. Within this area, small farming settlements dating back to the 1880s provided labor, and people moved from one mine or one ranch to another as the economics of the region evolved.

The history of mining has always been fraught with the divisiveness of humans bent upon the acquisition of wealth and the power that comes with it. People have resorted to inhumane ways to protect their stake in the proverbial "glory hole" at the expense of a living workforce. The history of Terlingua contains its share of stories of claim jumpers and swindlers.

Early historical accounts of the existence of cinnabar (quicksilver ore, a source for mercury) are sparse, and the more significant events occurred in the late 1800s. Juan José Acosta was a resident of the small farming community of Terlingua located along Terlingua Creek. Acosta was born in 1828 in Mexico, but by the 1880s, his family lived and farmed along the banks of Terlingua Creek. He and other relatives are buried there in the Acosta family cemetery. According to historical accounts, in 1884, Acosta took a sample of cinnabar-rich rock to a merchant named Klein in Alpine to have it assayed. Klein and Acosta agreed to develop the prospect, but apparently, Klein sold the claim to a group from California that began the first operations in the Big Bend at "California Hill." Production did not occur until 1894, when the speculators finally sold the claim to developers from the Marfa and Mariposa Mining Company. The first furnace was erected in 1899, and by the turn of the 20th century, word had spread about the quicksilver discovery in the Big Bend of Texas.

A similar event occurred east of the Terlingua Mining District at Mariscal Mountain. Cinnabar was first discovered by rancher and storekeeper Martín Solís at Mariscal Mountain. Solís shared his discovery with US Customs inspector Dennis Edward (Ed) Lindsey, and Lindsey filed mining claims and began prospecting, not including Solís as a partner.

As more prospectors and speculators descended on Terlingua, the extent of the geologic exposures of mercury ore became apparent. During the first decade of the 20th century, mining

endeavors covered a narrow 20-mile-long area between the settlement of Lajitas on the Rio Grande stretching eastward to what today is the community of Study Butte. In this area, about 20 mines were developed, but the most productive were Mariposa, Chisos/Rainbow, and Study Butte Mines.

The remoteness of the area and the difficulty and cost of obtaining necessary equipment and supplies, coupled with the nature of the cinnabar reserves, caused problems for many mercury producers in those early years. A promising vein would quickly play out, leaving the miners probing in desperation for other "lines" to follow in their search for mineable ore. The high up-front investment costs without a timely return from the mines drove many companies into default within a few short years. This led to corporate restructuring that allowed the mine to continue operation or mergers that infused the operation with new funds. Even then, rapid turnover in land ownership and corporate control characterized the Terlingua Mining District throughout its history.

Howard Perry started his cinnabar "roasting" effort with four retorts but soon realized the need for more efficient processing equipment. In 1905, when the Colquitt-Tigner operation shut down, Perry leased its 10-ton Scott furnace and began processing 15 tons per day through it. Geologist William B. Phillips became Perry's first superintendent of the Chisos Mine. Another prominent geologist, J.A. Udden, became Phillips's consultant, and together they provided the vision of the massive ore reserves under Perry's ownership. In 1905, Perry contracted for a 20-ton Scott furnace to be built, which further established the Chisos as the dominant producer in the Terlingua District.

Perry was an ultimate capitalist whose shrewd management of his investments drove the company for about four decades. Although the Chisos Mine proved to be the largest producer of mercury in the region, Perry's headstrong financial strategy was characterized by stubborn independence, and it led him headlong into the collapse of his dominion over the Terlingua District. Perry's demeanor alienated some and earned him the nickname of "El Perro," Spanish for "the dog."

Mercury production fluctuated with the ability of the mines to extract and process ore and was heavily dependent on changes in market value for quicksilver. Demand was high during the war years, and prices dropped thereafter. Difficulties with production, maintaining furnaces where the ore was roasted, the problem of water flooding the deeper mine shafts, and a host of other factors forced many companies to cease operations until market prices became favorable or until technical problems could be overcome.

Ranchers and farmers along Terlingua Creek and the small farming settlements, known to the local residents as La Coyota and Terlingua de Abajo, supplied not only produce for themselves but also surplus for the mining communities in upper Terlingua and Study Butte. These ranches and farming communities also supplied the majority of wood for the mine furnaces.

The sense of place for historically connected Latino families is related to where their families lived and worked and also to how many times they had to relocate due to the sporadic and seemingly capricious openings and closings of mines where one could get work. Home and community were frequently tied directly to the productivity of a particular mining venture or other activity that provided the connection of family to place. As families moved from job to job, home became, for that period, associated with the place where the employment provided sustenance. For those families who owned land, the sense of place was tied to their local realm of interaction with neighbors and the larger community.

The stories contained in this book come from oral histories; mining company records; county birth, death, and tax records; and church records to reveal the human history of Mexican workers and their families. This small tome makes no attempt at comprehensive coverage of the mining era. Author Kenneth Ragsdale has researched and presented that most admirably, and his work is referenced in the bibliography. Although Anglos controlled the mining businesses, the second portion of this book is devoted to the Hispanic farmers, ranchers, mine workers, and

their families and will discuss the living conditions and domestic activities of these families. The book covers nearby settlements (Terlingua de Abajo, La Coyota, Lajitas, Castolon, Study Butte, and others) that contributed to and supported the mining operation. These settlements combine conceptually to form the greater area called Terlingua. The federal acquisition of land for a park in the 1930s and 1940s altered the geography and forced the relocation of many farmers and ranchers. The final chapter discusses the abandonment of Terlingua following the decline in demand for mercury and how the ghost town was reoccupied in the last three decades of the 20th century.

One

MINES

Between 1903 and 1907, a rush of prospectors and developers descended on the area, and the Marfa and Mariposa Mining Company, Texas Almaden Mining Company, and Big Bend Cinnabar Mining Company established major operations between California Hill and Study Butte. The earliest location centered on the Mariposa Mine. By 1910, the Mariposa shut down operation, and a few miles to the east, the Chisos Mine became the major producer and remained so until the Chisos Mining Company went bankrupt in 1937. As the Chisos Mine began successful production in 1903, the Study Butte area was also being prospected and developed by the Texas Almaden and Big Bend Cinnabar Mining Companies. Around 1907, the Lone Star Mine located near the Mariposa also began production. Between California Hill and the Chisos operation was the Colquit-Tigner (Waldron) Mine. The growth and location of "Terlingua" followed the development of the mining industry and centered for periods where the major production occurred. The earliest location centered on the Mariposa Mine. After the Mariposa shut down, the Chisos Mine assumed the name Terlingua.

There were other mercury-producing districts peripheral to the Terlingua District. The Buena Suerte District consists of the Fresno and Whit-Roy Mines operated at the Contrabando Dome north of Lajitas. The Mariscal Mining District is located about forty miles east and today is within Big Bend National Park. There was also sporadic prospecting around Adobe Walls Mountain, at the Fernandez Mine on the south side of Christmas Mountains, and at Black Mesa north of California Hill.

Between 1941 and 1945, World War II spurred new interest, and the Fresno and Whit-Roy Mines were developed. The Esperado Mining Company reopened the Chisos Mine, but by 1947, all mines in the district were closed because of falling market prices. Between 1965 and 1973, there were sporadic attempts at production at the Lone Star Mine and by the Diamond Shamrock Corporation at Study Butte and Anchor Mining Company at Fresno Mine.

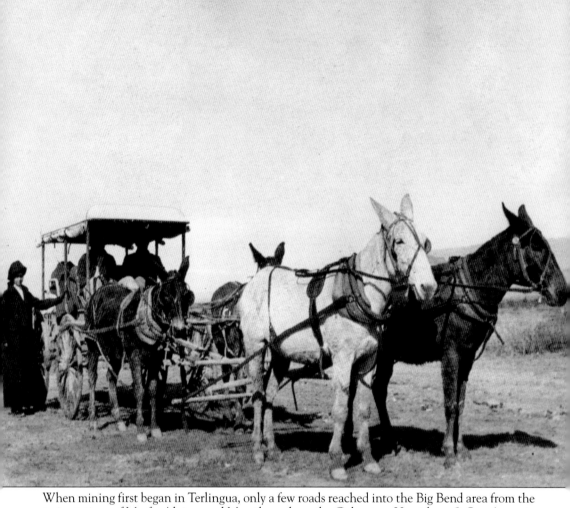

When mining first began in Terlingua, only a few roads reached into the Big Bend area from the train stations of Marfa, Alpine, and Marathon along the Galveston, Harrisburg & San Antonio railroad. One dirt track led south from Marathon to the mining community of Boquillas, Texas, and another ran south from Marfa to the Terlingua area. It took travelers two days riding in a mule-drawn hack to reach the remote area. C.W. Hawley, hired in 1905 as bookkeeper for the Mariposa Mine, devoted two entire chapters in his book *Life Along the Border* to his excursion in this contraption. The passengers and driver alike packed guns of various kinds, making Hawley wonder what kind of place he was moving to. The road led south to an overnight stop and then went down Fresno Canyon to the small settlement of La Jitas on the Rio Grande before completing the trip at Mariposa. (Photograph from Glenn Burgess collection, courtesy of Jack Burgess.)

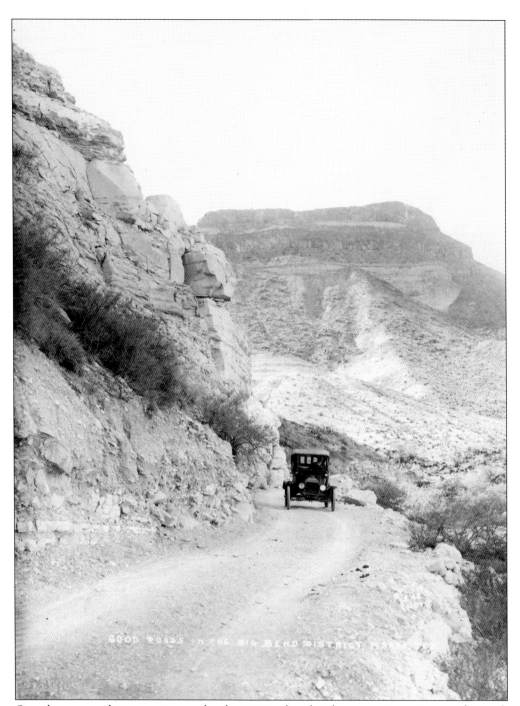

Over the years, as the county improved and maintained roads, it became easier to transport livestock and other products to and from the railway, benefiting ranches, mines, and other businesses. After the Chisos Mine began operation, other roads were improved to link to the railway not only at Marfa but also at Alpine and Marathon. Most roads remained unpaved until the 1950s, and some were not paved until the 1960s. Big Bend still remains one of the most remote parts of the United States. (Courtesy of Duncan Collection, Marfa and Presidio County Museum.)

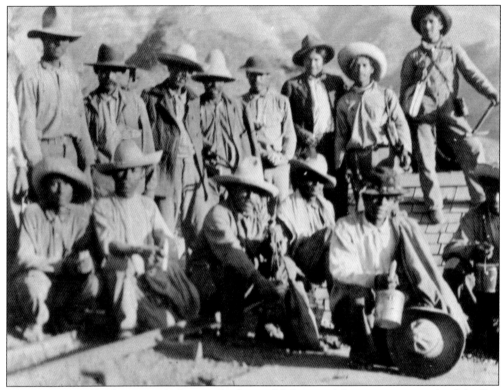

The discovery of lead, zinc, and silver in the Sierra del Carmen Mountains just south of the Rio Grande in the early 1890s drew workers from the Sierra Mojado and San Luis Potosi mining regions. The movement of ore from Mexico into the United States prompted the US Customs Service to appoint Dennis Edward (Ed) Lindsey as it first officer in the area. Lindsey established his headquarters across the river from Boquillas del Carmen in 1894. In 1910, a six-mile-long aerial tramway was constructed to bring ore into the United States. This prompted construction of new roads to the railway at Marathon. (Both Harris Walthall Collection, courtesy of the National Park Service.)

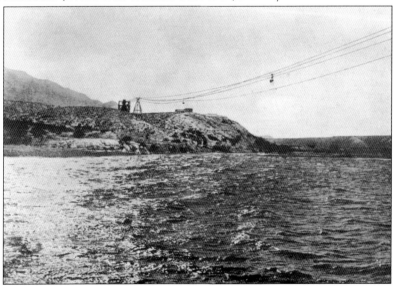

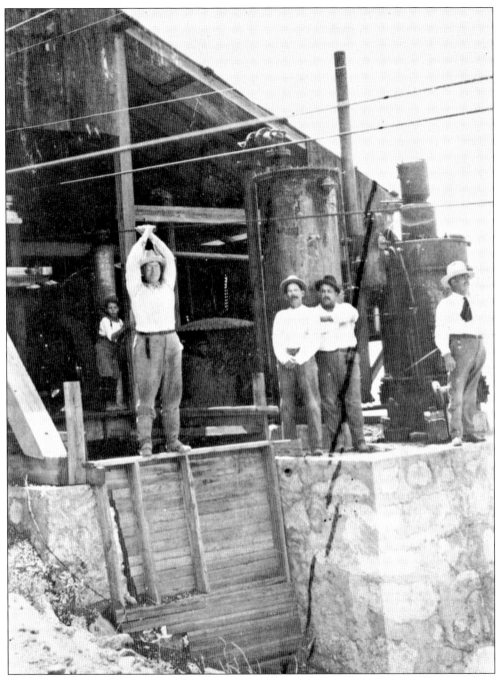

The tramway was driven from the loading terminal in Mexico and was powered by a coal gas generator. Prior to the development of natural gas in the 1940s and 1950s, almost all gas for heating and lighting was manufactured from coal. The tramway had a capacity of 250 tons per day. Ore was brought down to this loading terminal from the mines via a smaller cable tram. The large tramway extended 2.25 miles from the high cliffs of the Sierra del Carmen to the Rio Grande and then 3.75 miles from the river to the discharge terminal. (Harris Walthall Collection, courtesy of the National Park Service.)

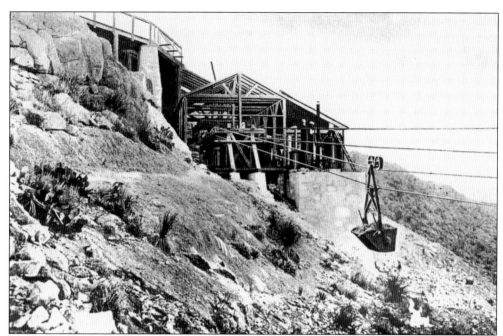

From the loading terminal (above) to the discharge terminal (below), this six-mile-long tramway had four tension stations placed strategically to maintain proper tension on the cables as the tram crossed steep and uneven terrain. Steel cables were also called "ropes." The track ropes were one inch in diameter on the loaded side and three quarters of an inch on the empty return side. The tramway also had 15 water carriers that held 40 gallons each. Water was collected from the Rio Grande and held in a tank until needed at the mine or at the discharge terminal. From the discharge terminal, ore was hauled in wagons drawn by traction engines to the railway at Marathon. (Both Harris Walthall Collection, courtesy of the National Park Service.)

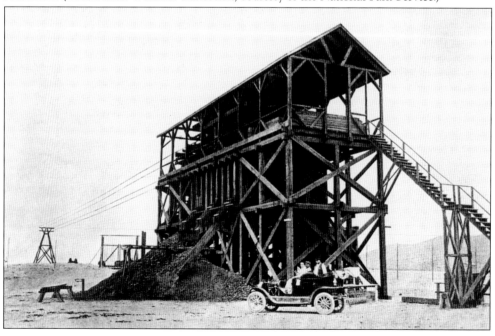

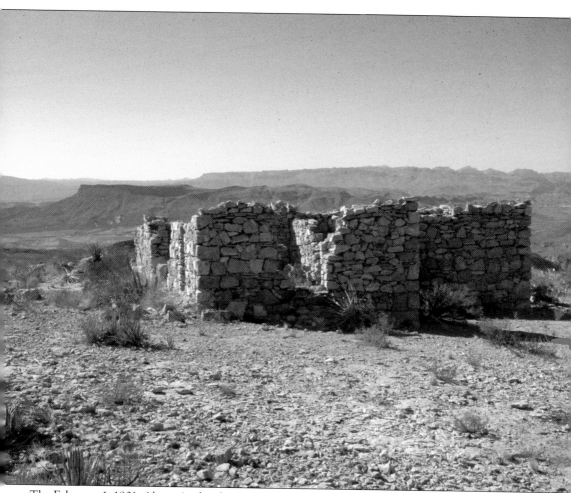

The February 1, 1901, *Alpine Avalanche* carried an article announcing that F.D. Coltrin, manager of the US Quicksilver Mining and Refining Company's property in Terlingua, was in El Paso. He mentioned that about a half dozen companies were working in the area with good results. At that time, no mine in the district had penetrated deeper than 100 feet, and good quality cinnabar was plentiful close to the surface. These optimistic attitudes prevailed for a short time until financial shortages, unexpected depletion of ore reserves, overestimation of potential production, and general mismanagement forced many companies to shut down operations. Companies changed business names, changed management, and sold less productive properties in order to resume business, but the rise and fall of owners and operators typified the history of the Terlingua Quicksilver District. Today, all that remains of Coltrin's time in the Big Bend is the name Coltrin's Camp on old topographic maps and these ruins of a large rock house above Tres Cuevas Mountain. (Photograph by Tom Alex.)

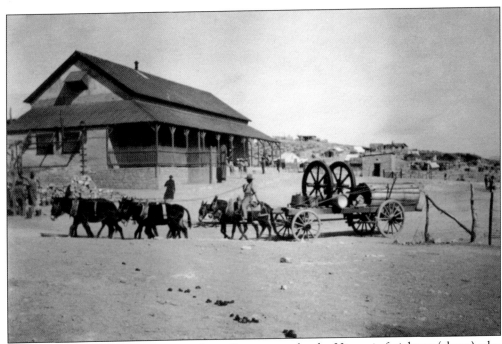

The constant need for equipment and supplies was met by the Hispanic freighters (above) who regularly hauled loads from the railway in Marfa, Alpine, and eventually from Marathon. The Hispanic work ethic was the underpinning of the successfulness of the Terlingua Quicksilver District and went without due recognition. A schism between Anglo and Mexican culture pervaded the first half of the 20th century, and it has taken generations to overcome the prejudices of the past. Below, Martín Zamarrón and others clean up after a fire at a Chisos Mine building. The service of hardworking Latinos most often was given in the background, and their intense labor usually went unrecognized, save for the families who realized the personal rewards of hard work. (Above, courtesy of Junior Historians Collection, Marfa Public Library; below, courtesy of María Zamarrón Bermúdez.)

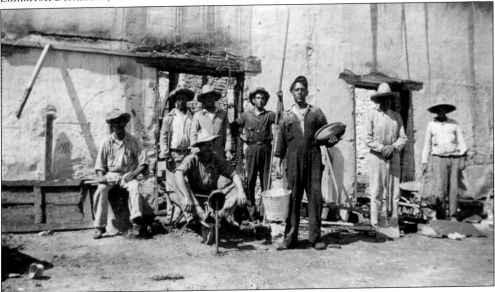

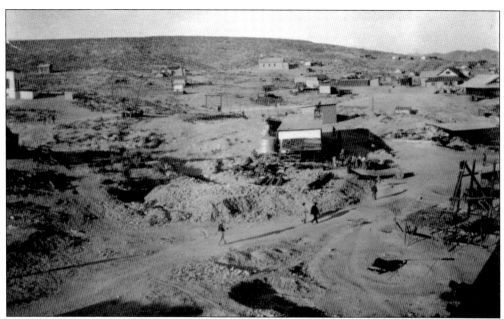

Looking north from the top of the No. 8 shaft, the South Lafarelle Shaft (at extreme right) was one of the earliest penetrations connecting with the 87-foot level of Chisos Mine. The No. 8 shaft at the Chisos Mine (below) was the highest and most visible in the Chisos complex. "El Ocho," as the Hispanic workers called it, reached down to the 250-foot level. In the foreground, a water hauler is supplying El Ocho. Between 1911 and 1912, most ore came from the No. 3 shaft and, from 1913 to 1914, from the Nos. 3 and 1 shafts. Between 1915 and 1919, the best production came from the 550-foot level. The No. 9 shaft penetrated to the 750-foot level. (Above, courtesy of Junior Historians Collection, Marfa Public Library; below, photograph by Glenn Burgess, courtesy of Jack Burgess.)

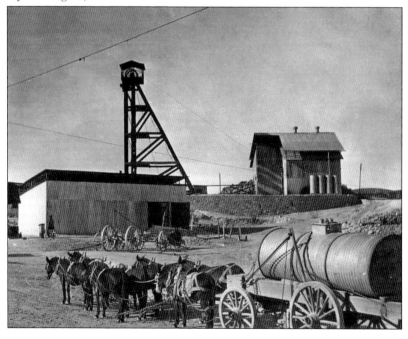

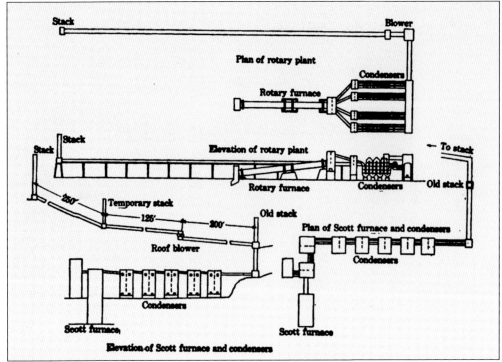

The 1931 report to the US Bureau of Mines by C.N. Schuette included the above cross-section diagrams of the Gould rotary furnace and Scott furnace at the Chisos Mine. Below, the Chisos Mine Scott furnace was eventually enclosed in this large building. The top of the head frame of the No. 8 shaft is visible above the furnace building. (Above, courtesy of the US Bureau of Mines; below, courtesy of Junior Historians Collection, Marfa Public Library.)

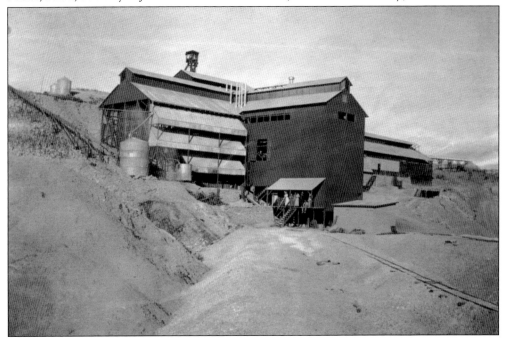

During the height of successful operation, the Chisos Mine was an impressive sight with extensive ore-processing structures spread widely below the No. 8 shaft, at center above. In 1931, C.N. Schuette described typical mining operations: "Development consists of running crosscuts to intersect the ore-filled fissures; these are then followed by drifts. 'Follow the ore' is the rule here, as elsewhere. In the old workings of the mariposa mine, under California Hill, this was done not only on the different horizons, but the ore was also followed up and down in the exploratory drifts, resulting in an amazing series of passages resembling the burrows of a rabbit warren." (Above, photograph by George Grant, courtesy of the National Park Service; below, photograph by Glenn Burgess, courtesy of Jack Burgess.)

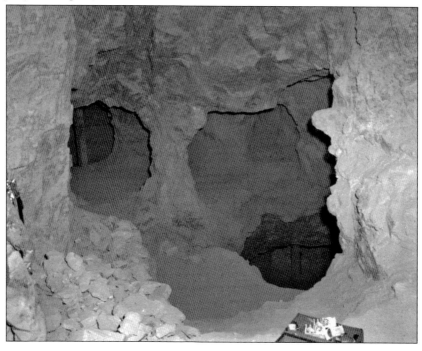

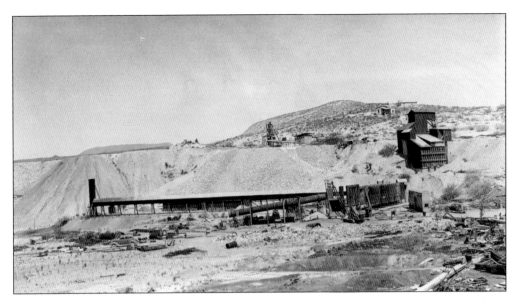

The decline of mining struck most companies, and mining engineer William D. (Billy) Burcham fell into financial difficulties in 1942 at the Study Butte Mine, the same year the Chisos was shut down. Attempts to resurrect both the Study Butte and the Chisos Mines passed through several mergers of mining companies, and in 1943, Burcham joined the Esperado Mining Company, which purchased the Chisos Mine and attempted to reopen it. In 1943, the general state of disarray at the Chisos Mine is evident above in the abandoned Gould furnace (center), and the piles of discarded debris scattered about the area below the furnace. During W.D. Burcham's 1943 inspection of the old abandoned Chisos infrastructure, he also captured the image below of the Rainbow Mine complex. (Both W.J. Burcham donation, courtesy Museum of the Big Bend.)

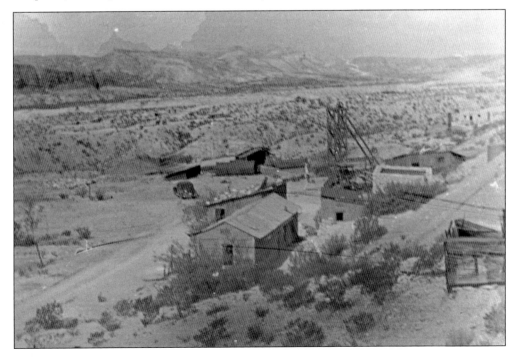

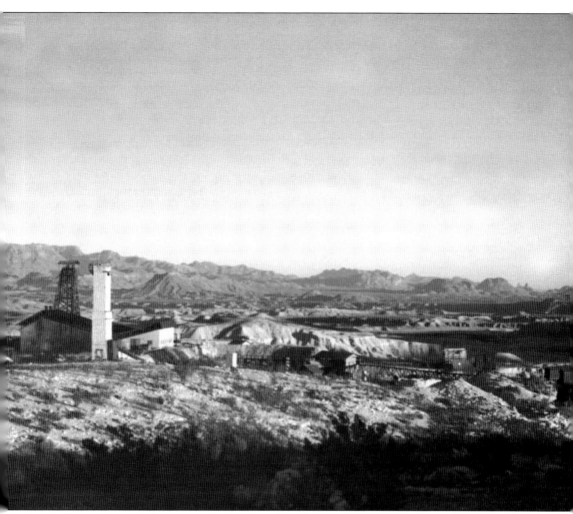

At the Chisos Mine, looking east, the final condenser stack and the El Ocho head frame stand at left, and the main furnace and processing plant are below, to the right. This photograph was taken in the 1940s during the decline of mining. Postwar economics and fiscal mismanagement marked the demise of Howard E. Perry's dominion over Terlingua. By this time, Perry had invested heavily in silver mining at Sierra Blanca and a gold mining venture in Canada, and his financial resources were spread thin in spurious investments. The addition of government-imposed control over the working conditions for the miners that should have been part of the operation from the beginning cost Perry additional revenue. His termination of longtime trusted associate Robert Cartledge was just one more blunder. Bankruptcy forced the sale to Esperado Mining Company, which tried unsuccessfully to continue operations. After total bankruptcy, Howard Perry died in his sleep in 1944. (Photograph by Glenn Burgess, courtesy of Jack Burgess.)

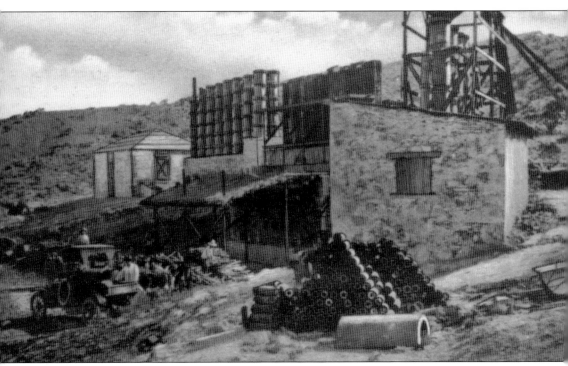

While the Chisos Mine operated, 40 miles east at Mariscal Mountain, Ed Lindsey began development of the mineral deposits there. After essentially swindling the quicksilver discovery from Martín Solís, Lindsey began extracting ore. Between 1903 and 1906, Lindsey extracted a small amount of ore and hauled it to Terlingua for processing. After Lindsey lost his quicksilver operation at Mariscal, W.K. Ellis began extracting and processing the rich deposits in 1916. The Ellis processor was a simple retort to heat the cinnabar ore and clay pipe tubes to condense the mercury vapors for collection into cast-iron flasks. (Courtesy of the Ross Maxwell Collection, National Park Service.)

ELLIS QUICKSILVER WORKS

1916 - 1919

Ellis was the first to process mercury ore on Mariscal Mountain. He discovered the valuable ore deposit in what was to become the main shaft. In 1916 he acquired a lease for the exploration of minerals on Section 33, Block G5, from the Texas and Pacific Railway Company. Record-high mercury prices brought on by the need for mercury in bomb makers during World War I allowed Ellis to secure financing and build a reduction works. Between 1916 and 1919 Ellis and his workers produced 894 flasks of mercury.

It is probable that the North Ellis Works, which is smaller in capacity and less uniform in construction, was built first. This reduction complex was then superceded by the larger-capacity, uniformly constructed South Ellis Works. The Ellis works were located on a direct path below the main shaft. Just above the plains below. Ore was brought from the mine, sorted, crushed, and moved by gravity to an inclined tramway. The tramway delivered ore down 80 feet in elevation to a concrete four-compartment ore bin, which fed the nearby retorts.

INCLINED RETORTS AND CONDENSERS

The reduction of mercury ore requires heating the ore until the mercury is released as a vapor from the rock. This vapor is then cooled to condense and collect the mercury. Both the North and South Ellis Works used essentially the same technology: inclined retorts to heat ore and air-cooled condensers to condense the mercury vapor. The two complexes differ primarily in size and in capacity.

The inclined retort is a relatively simple and old technology, used for the treatment of high-grade ore. Retorts are commonly used in the early stages of the development of a prospect because they are relatively inexpensive to construct, but they require comparatively high labor and fuel expenses, subject operators to a high risk of mercurial poisoning, and wear out quickly. The retort is charged from the top with crushed ore and sealed shut, so there is almost no oxygen present. As the ore is heated by a fire in the firebox below the retort, mercury vapors rise up the incline and out the manifold to the condenser. Tailings are periodically removed from the bottom of the retort, and the retort is recharged with ore at the top.

In the condenser, the vapor flows through large air-cooled ceramic pipes, condensing and running down the pipes as liquid mercury. The mercury runs down an incline at the base of the pipes and through a small opening into a collection gutter. In the South Works this gutter runs directly into the bottling building where the mercury was bottled for shipment. The North Ellis condenser forced the vapor up and down five pipes, while the South Ellis condenser forced vapor across 16 pipes.

Vapor Condensing Path — Diagram Only

South Ellis Plan

North Ellis Plan

Scale: 3/32" = 1' - 0"

Site Key — The finished product a 76 pound flask of quicksilver- bottled at the site and ready to ship to market.

South Condenser — Section AA, Scale: 1/2"=1'

North Inclined Retort — Section BB, Scale: 1/2"=1'
Reconstructed Section, see HAER report for sources

Between 1917 and 1919, the Ellis mine produced 894 flasks of quicksilver, but Ellis failed to keep up his interest payments. By 1919, the land reverted to the State of Texas. The rapid increases in the price of quicksilver during World War I brought a rush of prospectors into the Big Bend, and the operation at Mariscal was acquired by Billy Burcham. (Courtesy of the Historic American Engineering Record, National Park Service.)

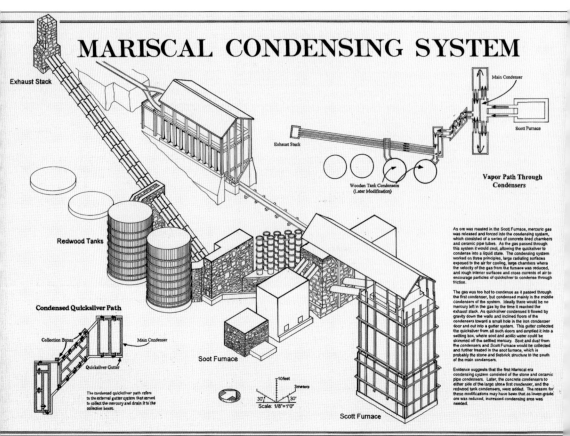

MARISCAL CONDENSING SYSTEM

Exhaust Stack

Main Condenser

Scott Furnace

Exhaust Stack

Wooden Tank Condensers
(Later Modification)

**Vapor Path Through
Condensers**

Redwood Tanks

As ore was roasted in the Scott Furnace, mercuric gas was released and forced into the condensing system, which consisted of a series of concrete lined chambers and ceramic pipe tubes. As the gas passed through this system it would cool, allowing the quicksilver to condense into a liquid state. The condensing system worked on three principles, large radiating surfaces exposed to the air for cooling, large chambers where the velocity of the gas from the furnace was reduced, and rough interior surfaces and cross currents of air to encourage particles of quicksilver to condense through friction.

The gas was too hot to condense as it passed through the first condenser, but condensed mainly in the middle condensers of the system. Ideally there would be no mercury left in the gas by the time it reached the exhaust stack. As quicksilver condensed it flowed by gravity down the walls and inclined floors of the condensers toward a small hole in the iron condenser door and out into a gutter system. This gutter collected the quicksilver from all such doors and emptied it into a settling box, where soot and acidic water could be skimmed off the settled mercury. Soot and dust from the condensers and Scott Furnace would be collected and further treated in the soot furnace, which is probably the stone and firebrick structure to the south of the main condensers.

Evidence suggests that the first Mariscal era condensing system consisted of the stone and ceramic pipe condensers. Later, the concrete condensers to either side of the large stone first condenser, and the redwood tank condensers, were added. The reason for these modifications may have been that as lower-grade ore was reduced, increased condensing area was needed.

Condensed Quicksilver Path

Collection Boxes

Main Condenser

Quicksilver Gutter

Soot Furnace

The condensed quicksilver path refers to the external gutter system that served to collect the mercury and drain it to the collection boxes.

10 feet
3 meters
30° 30°
Scale: 1/8"=1'0"

Scott Furnace

Under the management of Billy Burcham, the Mariscal Mine operated from 1919 to 1923, employing between 20 and 40 men. Most were Mexican nationals who came from San Luis Potosí and the Sierra Mojada Mining Districts in Mexico. More experienced workers earned $1.50 per 10-hour day. Lesser-skilled workers made $1 to $1.25 per 10-hour day, six days per week. Their pay usually returned to the company through the company commissary. The elaborate but inefficient processing plant was slow to produce, and the expense of building and operating it outweighed production profits. Eventually, the properties of the Mariscal Mining Company were sold at public auction to cover litigation against the company. (Courtesy of the Historic American Engineering Record, National Park Service.)

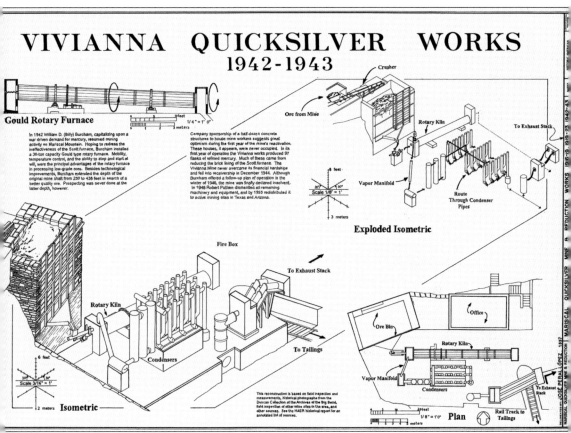

VIVIANNA QUICKSILVER WORKS
1942-1943

Gould Rotary Furnace

In 1942 William D. (Billy) Burcham, capitalizing upon a war driven demand for mercury, resumed mining activity on Mariscal Mountain. Hoping to redress the ineffectiveness of the Scott furnace, Burcham installed a 30-ton capacity Gould type rotary furnace. Mobility, temperature control, and the ability to stop and start at will, were the principal advantages of the rotary furnace in processing low-grade ores. Besides technological improvements, Burcham extended the depth of the original mine shaft from 250 to 436 feet in search of a better quality ore. Prospecting was never done at the latter depth, however.

Company sponsorship of a half-dozen concrete structures to house mine workers suggests great optimism during the first year of the mine's reactivation. These houses, it appears, were never occupied. In its first year of operation the Vivianna works produced 97 flasks of refined mercury. Much of these came from reducing the brick lining of the Scott furnace. The Vivianna Mine never overcame its financial hardships and fell into receivership in December 1944. Although Burcham offered a follow-up plan of operation in the winter of 1946, the mine was finally declared insolvent. In 1949 Robert Pulliam dismantled all remaining machinery and equipment, and by 1950 redistributed it to active mining sites in Texas and Arizona.

Exploded Isometric

Crusher
Ore from Mine
Rotary Kiln
To Exhaust Stack
Vapor Manifold
Route Through Condenser Pipes

Isometric

Fire Box
To Exhaust Stack
Rotary Kiln
Condensers
To Tailings

Scale 3/16" = 1'

This reconstruction is based on field inspection and measurements, historical photographs from the Duncan Collection at the Archives of the Big Bend, field inspection of other mine sites in the area, and other sources. See the HAER historical report for an annotated list of sources.

Plan

Office
Ore Bin
Rotary Kiln
Vapor Manifold
Condensers
To Exhaust Stack
Rail Track to Tailings

Scale 1/8" = 1'0"

During World Wars I and II, the quicksilver industry thrived. In 1942, W.D. Burcham organized the Vivianna Mining Company, secured the lease and reopened the old Mariscal Mine. During World War II, the Vivianna mine, with a new 30-ton capacity Gould furnace, began production at Mariscal Mountain. Many workers brought their families and, at first, built temporary dugout houses and simple jacals until more permanent rock houses were constructed. After the closing of the Mariscal Mine, most workers moved to the Study Butte and Terlingua Mines. (Courtesy of the Historic American Engineering Record, National Park Service.)

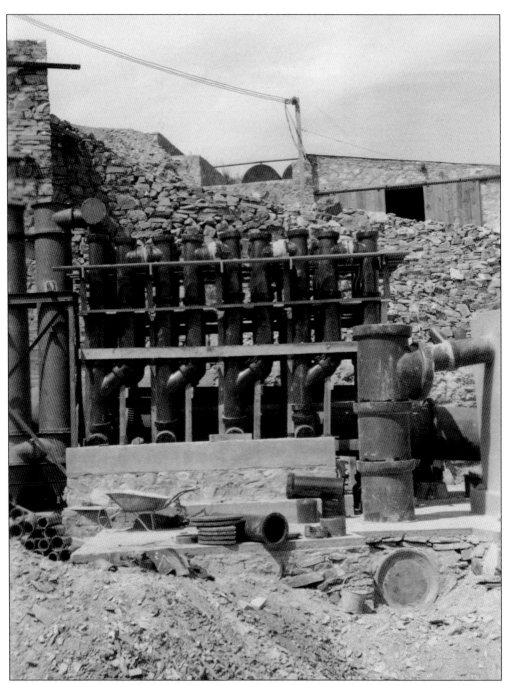

Between 1942 and 1943, the price of quicksilver declined, and the community of Mariscal, Texas, that had grown up around that mine was abandoned. New owners salvaged the furnace equipment (pictured) and moved the Gould furnace to the Maggie Mine in the Terlingua Mining District. Mine workers from Mariscal moved their families to the Terlingua Mining District, where they found employment. This illustrates the tenuous nature of living in the constantly changing economic environment during the first four decades of the 20th century. (Photograph courtesy of W.J. Burcham Collection; Museum of the Big Bend.)

West of the Chisos Mine, a deep trench was the first exploration at the Colquitt-Tigner (Waldron) Mine. In 1904, ore samples were being analyzed from this long and narrow cut, which became a main entrance to the Waldron Mine. A horizontal opening is called an "adit," and vertical openings are called "shafts." Below, "stoping" is the process of removing ore by following the ore body and hollowing out the mass of useable ore. It results in open "caverns." Stoping is used when the surrounding country rock is strong enough to not cave into the opening. Stoping is productive work in that it extracts ore, while the cutting of shafts, winzes, and adits to access ore bodies is considered "deadwork" that is required simply to gain access to the mineral deposit. (Both photographs by Frank Duncan, courtesy of Junior Historians Collection, Marfa Public Library.)

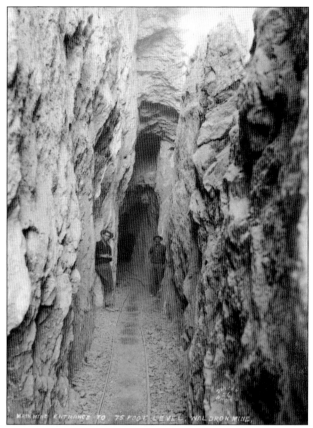

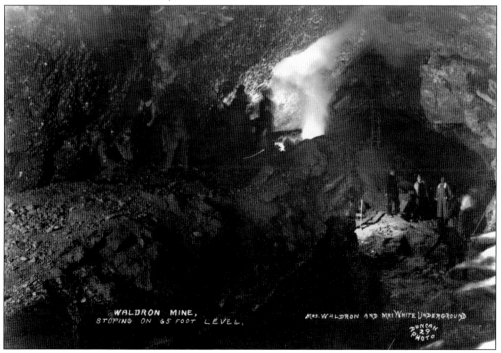

WALDRON MINE, STOPING ON 65 FOOT LEVEL.

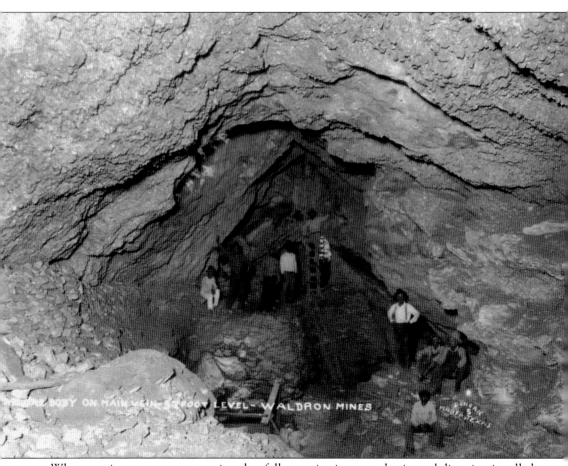

Where a vein occurs, ore extraction that follows veins in a near horizontal direction is called a "drift." The Waldron Mine consisted of about 900 feet of drifts on the main level. Much of the Waldron Mine consisted of natural-solution caves that were filled with sediment containing sulfide and chloride of quicksilver. The caves were up to 60 feet wide and a total combined length of about 340 feet. Stoping was done to extract the useable ore. (Photograph by Frank Duncan, courtesy of Junior Historians Collection, Marfa Public Library.)

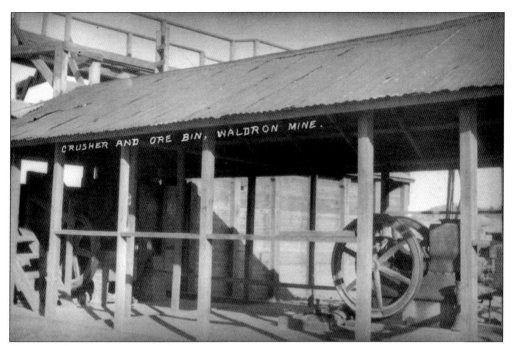

Ore from the mine was sorted by grade and then passed through a crushing machine to prepare it for the furnace. The Blake Crusher (pictured above and at right) was commonly used to prepare cinnabar ore for processing because its simple design produced the optimal size of rock fragments to pass efficiently through a Scott furnace. (Both Duncan Photo Collection, courtesy of Marfa-Presidio County Museum.)

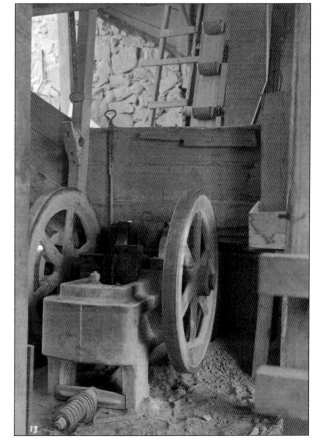

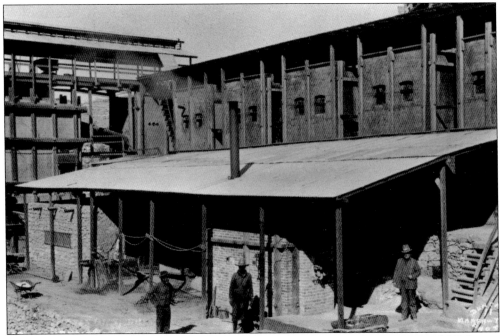

Waldron Quicksilver Properties operated this retort and 10-ton Scott furnace at the old Colquitt-Tigner mine, where ore from several sources was hauled and processed. For a time when the Waldron operation was shut down in 1905, the Chisos Mine leased the furnace. Below, the spent ore drops to the bottom of the furnace, where it must be removed and hauled to the tailings pile. In some cases, such material was added back into the new ore and reprocessed to extract the final remnants of mercury. (Both Duncan Photo Collection, courtesy of Marfa-Presidio County Museum.)

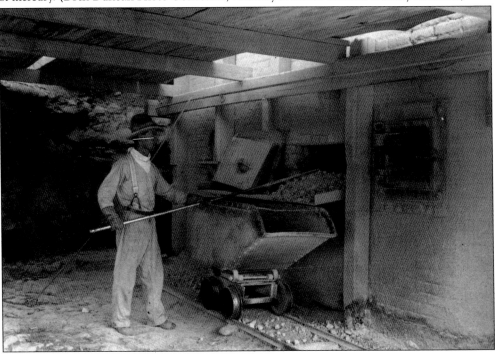

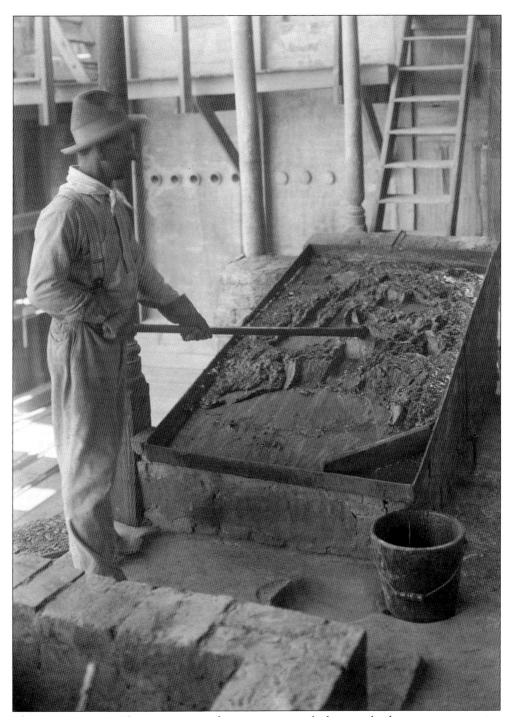

The entire sequence of processing cinnabar to extract quicksilver involved constant monitoring of the furnace output and ultimately to retrieving soot that was saturated with quicksilver from the furnace. This unidentified laborer is working the soot with a hoe on a sloping tray to allow liquid mercury to flow from the soot and drain into the bucket at the bottom of the bin. (Duncan Photo Collection, courtesy of Marfa-Presidio County Museum.)

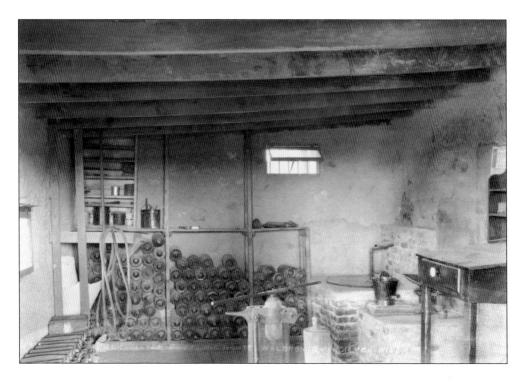

The bottling house (above) at the Waldron Mine is where cast-iron bottles were filled with liquid quicksilver. These flasks weighed 76 pounds when filled with mercury. Shown below, at the railway in Marfa, is the first shipment of quicksilver from the Waldron Mine. It was 7,500 pounds. (Both Duncan Photo Collection, courtesy of Marfa-Presidio County Museum.)

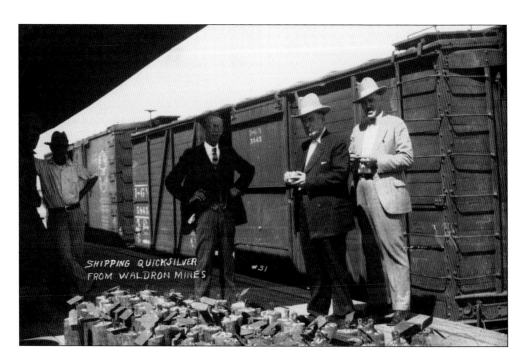

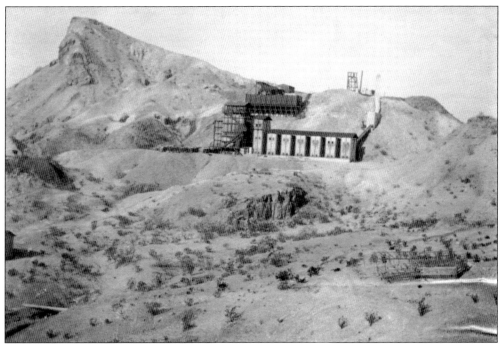

The Study Butte Mine lies at the eastern extent of the Terlingua Mining District, where cinnabar was discovered around 1902. The photograph above was taken early in the development of the Study Butte Mine, while construction was still underway. Heavy production began here around 1905, but most production occurred during World War I, when about 4,500 flasks of mercury were produced. Below, the Study Butte Mine consisted of two adjacent claims that were operated by the Big Bend Cinnabar Mining Company (head frame at far right on top of hill) and the Texas Almaden Mining Company, also referred to as the Dallas Company Mine (head frame at left center) (Above, photograph by Frank Duncan, courtesy of Junior Historians Collection, Marfa Public Library; below, W.J. Burcham donation, courtesy Museum of the Big Bend.)

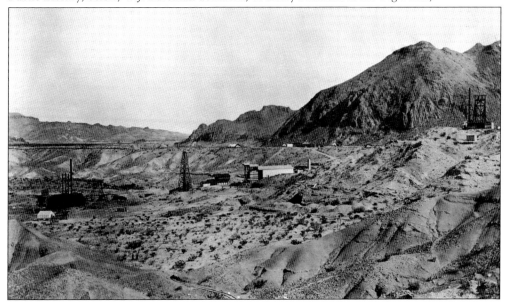

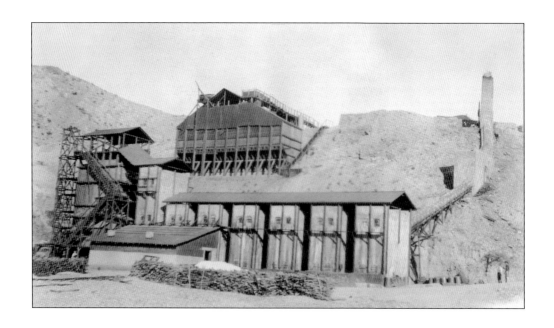

Between World War I and World War II, W.D. Burcham managed operations at the Study Butte Mine, which had (from left to right) a Scott furnace, a large primary condenser, and six secondary condensers. The furnace needed one and a half cords of wood per day. During a 31-month period, the mine bought over 2,500 cords of wood, costing between $4.50 and $10 per cord. About a quarter of the wood was hauled from Castolon, La Coyota, and Terlingua de Abajo. Below, in 1931, the Big Bend and Dallas Mines were operated by the Brewster Quicksilver Consolidated Company. The ore from the Big Bend Mine was treated in the two-shaft, four-tile Scott furnace of the Dallas Mine. The furnace treated 20 tons daily. (Both courtesy of W.J. Burcham Collection, Archives of the Big Bend.)

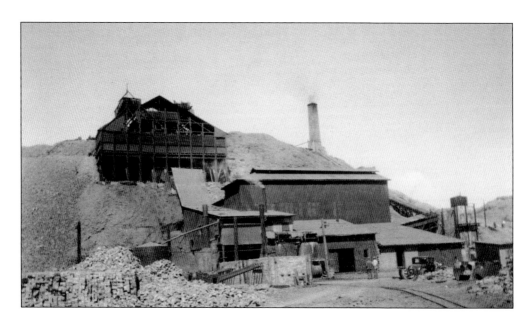

Pictured at center with two unidentified individuals is W.D. Burcham, who operated Study Butte Mine as well as several other mining operations, including the Mariscal Mine. The 1931 report by C.N. Schuette to the Department of Commerce Bureau of Mines described the problem many of the deeper mines encountered when they came to underground water. At the Study Butte/Dallas Mines, Schuette reported: "When the water is being pumped down in these mines, streams of water issue from 1-inch fissures in the walls of the drifts under enough pressure to strike the opposite wall. When these mines, which are connected underground, were reopened after the last shutdown it was necessary to pump at the rate of 1,000 gallons per minute 24 hours a day to lower the water level. After the mines are pumped down pumping at the rate of 300 gallons per minute for 10 hours a day suffices to hold the water." (W.J. Burcham donation, courtesy of Museum of the Big Bend.)

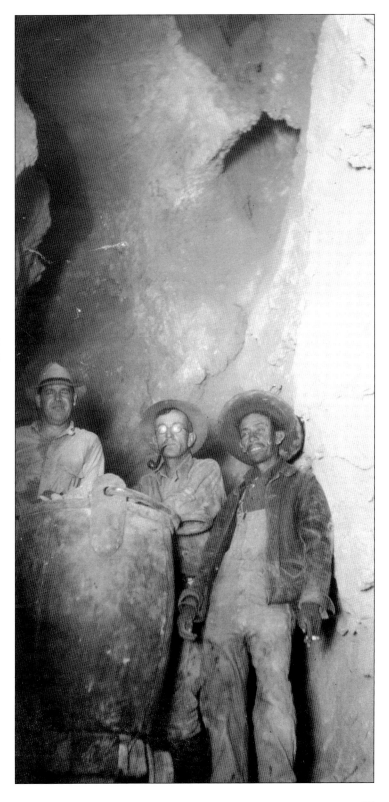

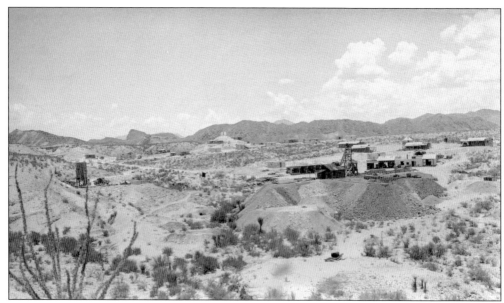

The 248 Mine was also owned by E.A. Waldron, and cinnabar was discovered here before 1902. By 1934, seven hundred feet of subsurface workings had been dug. The mine consisted of 13 levels penetrating down through a breccia pipe that formed as a solution cavern collapsed and was filled with rock debris from above. The breccia pipe was about 100 feet in diameter at the surface but expanded with depth. The lowest level of the mine, at 804 feet, cut into the Del Rio Clay. After 1940 (below), the mine was leased by Esperado Mining Company, which extended the mine to more than 7,000 feet, reaching down to the 804-foot level at the main shaft. (Above, courtesy of W.J. Burcham donation, Museum of the Big Bend; below, photograph from Glenn Burgess collection, courtesy of Jack Burgess.)

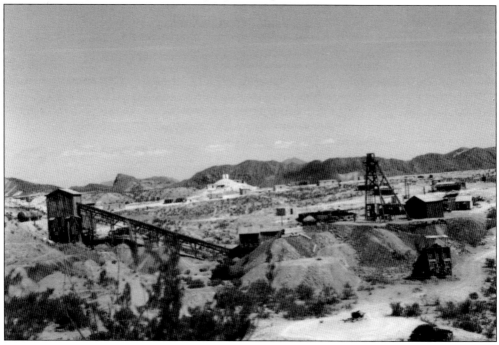

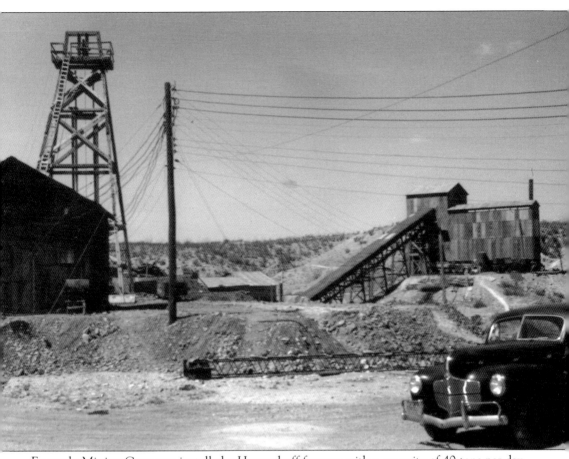

Esperado Mining Company installed a Herreschoff furnace with a capacity of 40 tons per day. Down in the mine, workers experienced high temperatures at the lower levels, and drilling exposed pockets of hydrogen sulfide gas in the breccia, though it dissipated once released. A forced ventilation system was required to make for safer working conditions. The 248 Mine encountered pockets of asphalt and tar, some of which was brittle, though others were liquid. In the early 1980s, lightning struck the head frame and set it afire. The head frame burned and collapsed into the main shaft, where it ignited subsurface tar deposits that continued to burn for months. The 248 head frame was one of the last remaining in the Terlingua District. (Photograph from Glenn Burgess collection, courtesy of Jack Burgess.)

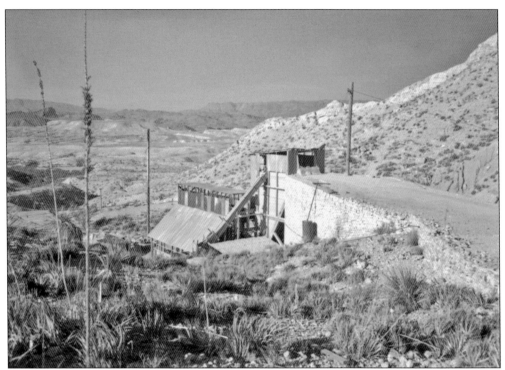

Above, west of the Terlingua District is the Buena Suerte District, consisting of the Contrabando Dome prospects and the Whit-Roy and Fresno Mines. Exploration of the Fresno began in the 1930s by Harris S. Smith and active mining and production began in the 1940s by Smith and Homer M. Wilson. Below, author Tom Alex and archaeologist Elton Prewitt stand at the Whit-Roy furnace on Big Bend Ranch State Park. (Above, photograph from Glenn Burgess collection, courtesy of Jack Burgess; below, photograph by Betty Alex.)

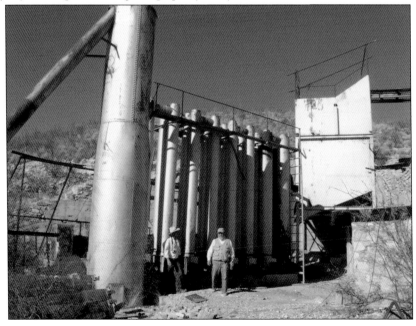

About two miles west of the Mariposa Mine, the principal operations extracted ore from the Maggie Sink, which is a breccia pipe extending down at least 600 feet below the surface. Around World War I, the principal workings consisted of trenches, pits, and shallow shafts. Between 1943 and 1946, an adit was dug to intersect the pipe at about 150 feet below the surface. By 1947, Robert Pulliam held the claim and extracted ore, and it was called Bob's Mine. This ruin stands above Maggie Sink and Bob's Mine. (Photograph by Tom Alex.)

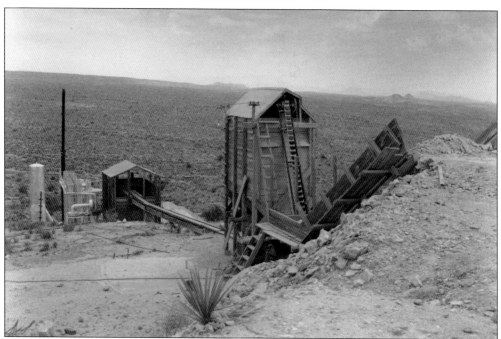

Above, the Lone Star Mine resumed extraction in this area and processed ore in this rotary furnace. Below is a detailed image of the furnace. At most mines, after production ceased, the equipment was sold off as salvage to help recover revenue. Today, only a few concrete foundations mark the location a short distance northwest of Maggie Sink. (Both photographs from Glenn Burgess collection, courtesy of Jack Burgess.)

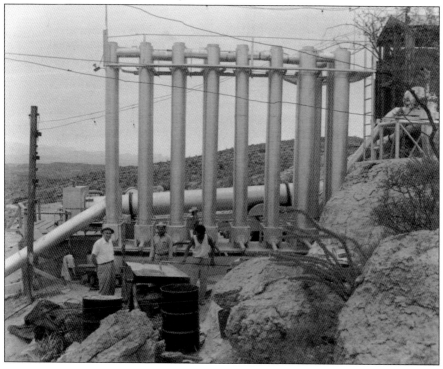

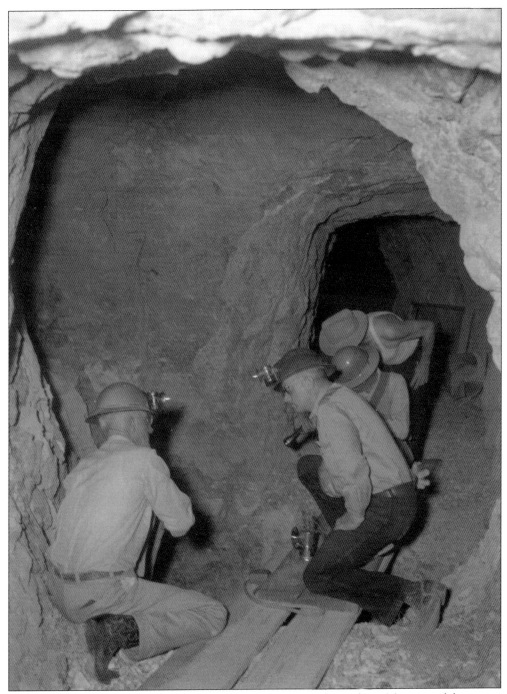

In early years, mine inspections were done routinely to assess the quality of the ore and determine the geologic conditions and potential for successful extraction. In later years, mining inspections were also required to assess the safety of the working conditions. Workers had to contend with sulfurous fumes, carbon monoxide, and high heat, and these conditions had to be constantly monitored. Ventilation systems and special ventilation shafts had to be cut to supply fresh air for the miners. (Photograph from Glenn Burgess collection, courtesy of Jack Burgess.)

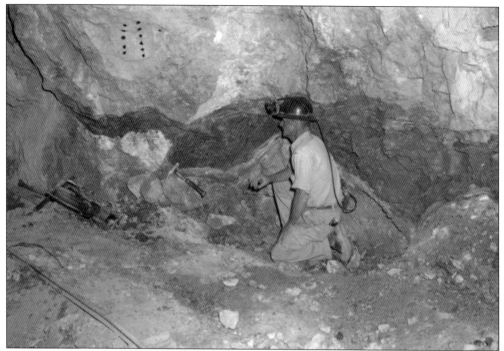

Above, a worker is inspecting rich ore in the darker colored band, and below, a worker is loading ore into the bucket for hoisting at the Lone Star Mine. For a period, the Lone Star followed this rich vein, but it slowly played out and required prospecting for additional lode. Workers hand separated the high-grade ore from the low grade so that the furnace operators could better regulate the processing. (Both photographs from Glenn Burgess collection, courtesy of Jack Burgess.)

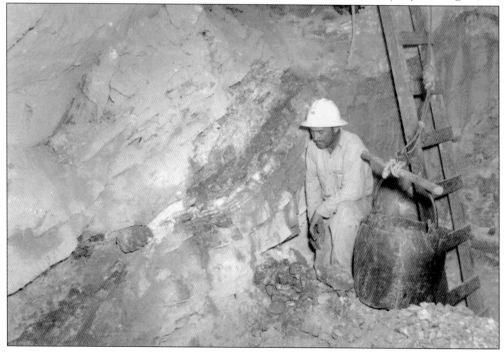

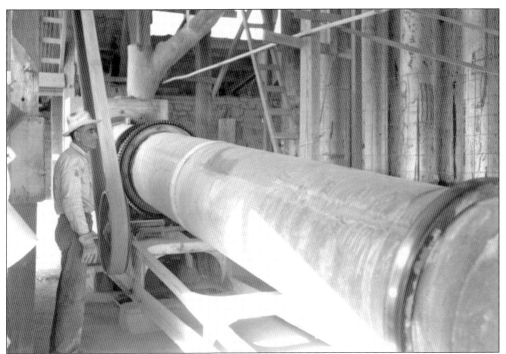

The operator of this rotary furnace spent long hours ensuring that constant ore feeding and processing took place. Mercury vapor from the furnace (long tube above) rises into the condensing chambers (above, upper right), where the vapor cools and liquid mercury condenses and runs down to the bottom. Below, workers gather liquid mercury for bottling. (Both photographs from Glenn Burgess collection, courtesy of Jack Burgess.)

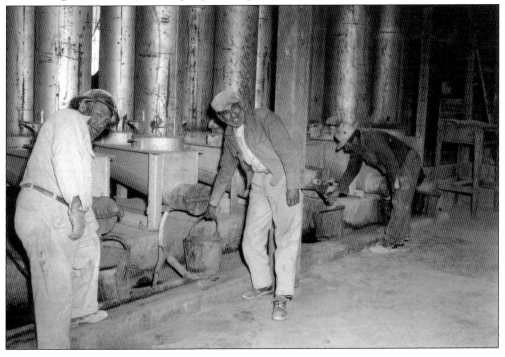

Once cooled and condensed into the liquid state, quicksilver is collected and poured into cast-iron bottles weighing 76 pounds when filled. The weight alone gave a sense of value and hinted at potential wealth. The hopeful look typifies the desire for the quick riches that quicksilver provided for only a few. The Lone Star mining venture was one of the latest in the line of boom-or-bust ventures in the Terlingua Mining District. (Both photographs from Glenn Burgess collection, courtesy of Jack Burgess.)

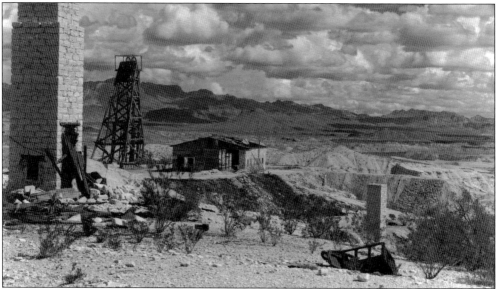

Mining in the Terlingua District waxed and waned for over a half century and was subject to fickle market fluctuations, but ultimately, the failure in Terlingua was typical of mining ventures worldwide. After World War II, later ventures followed the legacy of Howard Perry's Chisos Mine, but none provided the stability necessary to sustain an entire community like Perry's Terlingua. The memories of this period are carried on by the descendants of those who occupied the communities around the various mines and whose labor put wealth into the pockets of a select few. But the wealth of memories held by those who lived, worked, and bore children here is more valuable than anything the quicksilver could purchase. The Chisos Mountains in the distance are a timeless sentinel above the temporary rewards of the treasure-seekers. The movement during the 1930s and 1940s to establish recreational opportunities marked the transition from mining to a tourism-based economy. (Photograph by Glenn Burgess, courtesy of Jack Burgess.)

Two

FAMILIES

Between 1916 and 1920, the Mexican Revolution was a troubling time along the Rio Grande for both Mexicans and Anglo-Americans. Revolutionaries struck the US side of the border in search of materiel. Political turmoil in Mexico made it easier for bandits to plunder local settlements, calling themselves *revolutionistas*. The decade of revolution created a general sense of ill ease between Anglos and Mexicans along the border. By 1920, the government of Mexico had achieved a degree of stability, partially because the constitution of 1917 established the *ejido* system, allowing communal use of land that was formerly owned by the wealthy upper class. After 1920, some families who had fled their homeland returned to Mexico to reestablish a livelihood. However, during all this upheaval, workers in Terlingua and Study Butte experienced very little threat from the revolutionistas across the border.

For Hispanics, the priorities of life are health, family, and friends, and depending on circumstances, health took third place. The "family" includes the extended family of grandparents, aunts, uncles, and cousins. Families instilled in children the importance of honor, good manners, and respect for authority and the elderly. In the Hispanic world, religion is a significant part of daily activity. The church influences family life and community affairs, giving spiritual meaning to the culture. But where no church is available and the priest only shows up once every few months, religious affairs are dealt with appropriately and reasonably. A firm handshake can be a congenial expression but can also represent a signed contractual agreement. An *abrazo* (hug) and customary kiss on the cheek are also common greetings between women and men who are close friends or family.

Although most land and mining businesses were owned by Anglos, Hispanics composed the majority of the population. The integrity and resourcefulness of these people contributed greatly to the development of Terlingua, and Hispanic culture can be seen in the architecture and felt in the attitudes of longtime residents. This chapter focuses on a few Hispanic families for whom there are family photographs and good documentation; they are representative of the late-19th- and early-20th-century history of the area.

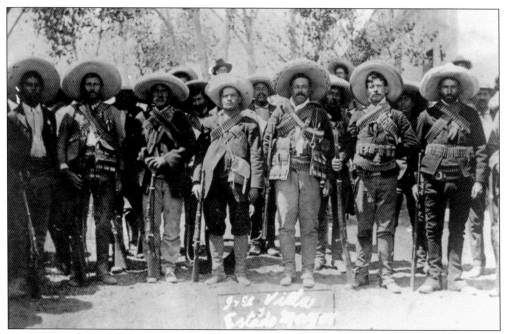

Economic and social problems in Mexico led to the original revolution of 1910. In need of weapons and supplies, Mexican revolutionaries made occasional raids across the US border to plunder ranches and settlements in search of riding stock, weapons, and other supplies. According to Everett Ewing Townsend, Pancho Villa had a stronghold in the Hechiceros Mountains, 30 miles south of Lajitas. The Mexican Revolution was a volatile and destabilizing decade, but by 1920, the Mexican government was stabilizing and diminishing border conflict. Many Mexican citizens fled to escape turmoil in Mexico, seeking refuge in the United States. Unfortunately, the great number of refugees could not be accommodated, and as in most conflicts of this nature, what they found were uncertain conditions that were, for a time, almost unbearable. (Both courtesy Junior Historians Collection, Marfa Public Library.)

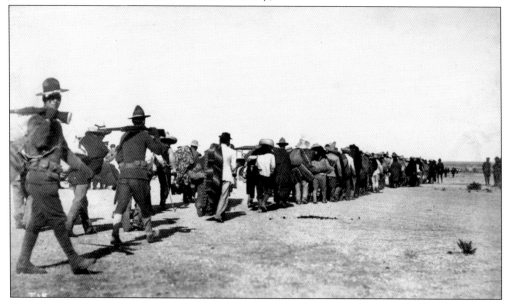

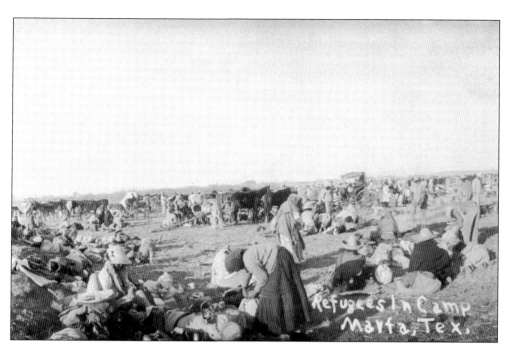

Those fortunate enough to find work in the mines of Terlingua or Shafter and those who found it in industries that supported those mines were able to endure the hardships of the time. Once the revolution ended, some returned to Mexico, but others stayed, eventually becoming US citizens. The meager goods they carried to America on their horses or on their backs were eventually replaced as their income allowed. Many came to purchase their own land and businesses. Many Hispanic families living in Terlingua today are successful heirs to the hard work and independent spirit of their forebears. (Both courtesy Junior Historians Collection, Marfa Public Library.)

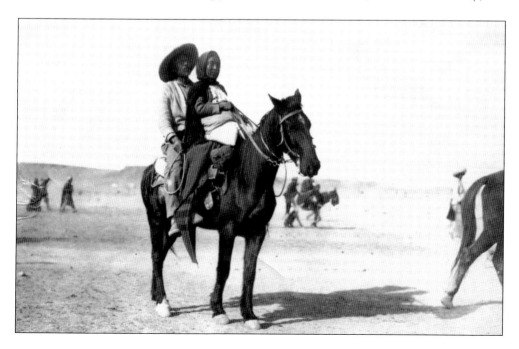

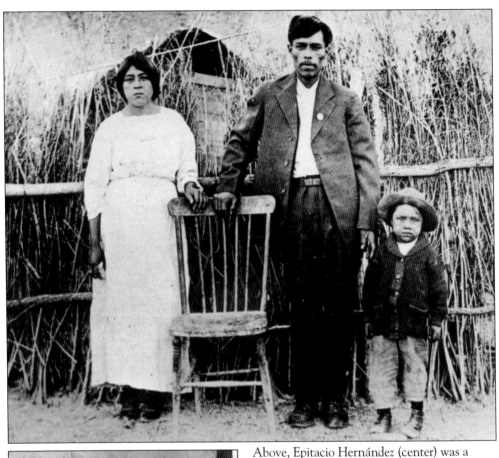

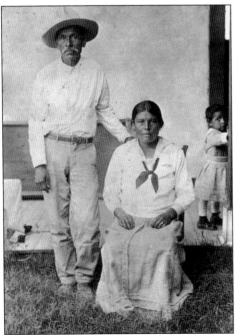

Above, Epitacio Hernández (center) was a typical mine worker in the Terlingua District. Born in Sierra Mojada, Coahuila, Mexico in 1896, he immigrated in 1918 and worked at Study Butte Mine from 1918 to 1919. He married Pioquinta Salazar (above, left) in 1920. By April 1922, Epitacio was working at the Mariscal Mine when his son Vidal (above, right) was born in Mariscal, Texas. In June 1924, Epitacio worked at Chisos Mining Company in Terlingua, and his son Panteleón was born. By 1940, the family had moved to Shafter, Texas, where Epitacio probably worked in the silver mines. At left, Gil Díaz and his wife were also at Study Butte from 1916 to 1919. Gil averaged about 18 shifts per month at $1 to $1.25 per shift. (Both courtesy of Museum of the Big Bend.)

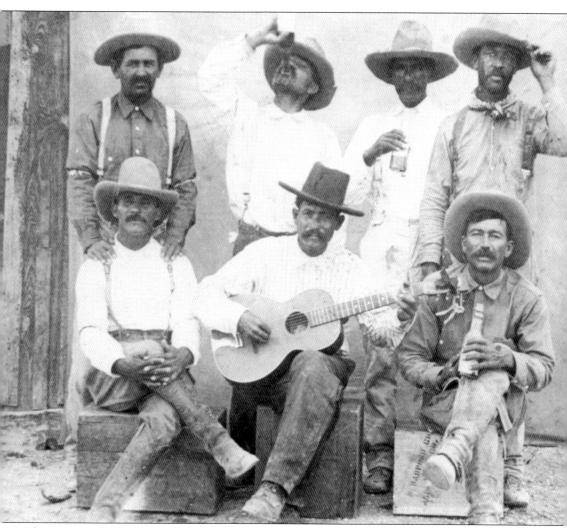

The men in this image were both farmers and freighters who hauled materials in the region. This was a time when cutting and hauling 3.25 cords of wood would earn about $32. Growing, picking, shelling, and bagging 660 pounds of beans would net about $80. One freight run often paid that much or more. Pictured in 1919 are, from left to right, (first row) Felix Valenzuela, Chon Catano, and Paz Molinar; (second row) Antonio Franco, Patricio Márquez, Bernardino García, and Sixto Chavarría. Their families lived near Terlingua de Abajo and La Coyota. The Molinar, Franco, and Valenzuela families owned land on both sides of Telingua Creek between the Chisos Mine and Terlingua de Abajo. Because we have historic records and photographs of these families, many family members are featured in subsequent images. There were many more families living similar lives in the Terlingua area. (Courtesy of Museum of the Big Bend.)

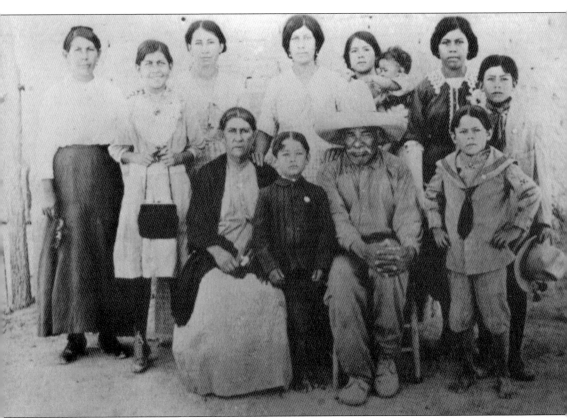

Severiano and Rita Chavarría moved to La Coyota in 1884. He was a ranch laborer and freight hauler. From left to right are (first row) Rita Ramírez Chavarría, Román Franco, Severiano Chavarría, and Manuel Franco; (second row) Maria Hinojos Chavarría, Juliana Chavarría, Valentina Chavarría Franco, Santos Chavarría, Cleotilde Ybarra Chavarría (holding Isabel Franco), Antolina Chavarría, and Benigno Franco. This picture was taken four years before Sixto Chavarría's birth. (Courtesy of Louisa Franco Madrid.)

After Severiano Chavarría's death in 1925, his son Ruperto continued the family farming business at La Coyota. By 1908, Ruperto owned a 640-acre tract that included the La Coyota village, and farmed about 40 acres of land at the confluence of Alamo Creek and the Rio Grande. Local residents referred to Alamo Creek as Arroyo de la Coyota. Here, Ruperto (center) is entertaining two young rangers at his home in 1901. While others in the settlement did not think of the rangers as friendly, the Chavarrías considered them friends. Ruperto and his wife, Angelita, never had children but were godparents to many children of the area. They also may have "adopted," or raised, several children. He died at the age of 74 and is buried in Alpine, Texas. (Courtesy Genoveva Ramírez Rodríguez.)

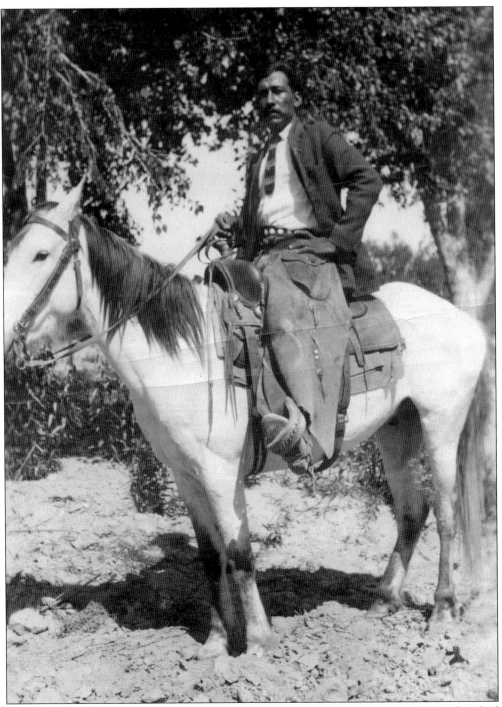

Pablo G. "Gordito" Chavarría, the brother of Ruperto, was born in La Coyota in 1901 and worked as a farmer most of his life. Pablo was married to Agustina Silvas on June 30, 1933, at Terlingua by the town's justice of the peace, Robert Cartledge. *Caballeros* (gentlemen), such as Pablo and his brother, were the solid foundation of their families and collectively contributed to the well-being of their communities. (Courtesy of Genoveva Ramírez Rodríguez.)

On the right, Angelita Galindo married Ruperto Chavarría in 1901. She maintained their farm and household along Arroyo de la Coyota (Alamo Creek). Angelita did not like to sew but made beautiful crocheted tablecloths and other crocheted items. Below, Santos Chavarría, daughter of Severiano and Rita Chavarría and sister to Ruperto, is shown at age 11 in 1901. There was one wedding at the Antonio Franco house along Terlingua Creek, a few miles north of Terlingua de Abajo. In 1920, Valentina Chavarría married Antonio Franco and Santos Chavarría married Vicente Franco—brothers marrying sisters. Antonio's son Benigno said they had a dance, and his father had a lot of fun dancing with all the relatives. These marriages led to a rich historic legacy in the region. (Right, courtesy of Genoveva Ramírez Rodríguez; below, courtesy of Louisa Franco Madrid.)

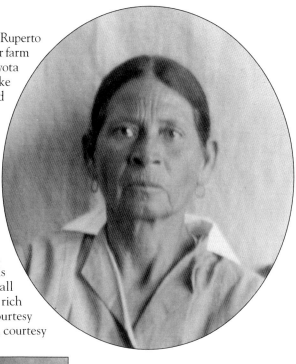

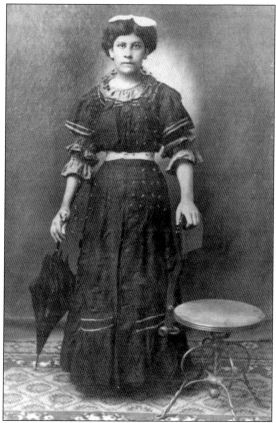

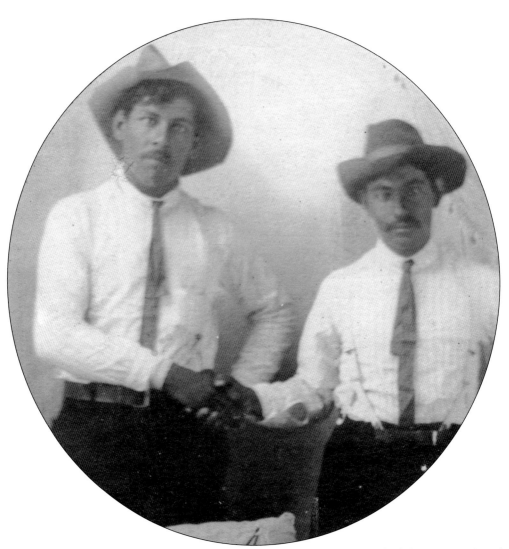

These are two of Ruperto's brothers, both born in La Coyota: Cecelio (left), born in 1897, and Domingo, born in 1899. Between June 1917 and October 1918, Domingo sold nearly 60 cords of fuel wood to the Study Butte Mining Company for $532.50. In June and July 1924, he earned $82.55 for hauling freight for the La Harmonia Company in Castolon, and in February and March, he earned $109.96 for hauling freight for the same company. He remained in the La Coyota area until at least 1932, working as a farmer and ranch hand. On June 3, 1922, Cecelio purchased a hat at La Harmonia in Castolon for $5.75. He paid $4 in "silver" and charged the remainder, but paid the balance on June 11. In 1932, Cecelio, age 35, married Catalina Tucar, age 18. She was born in Terlingua to José Tucar and Felipa Sánchez. The couple moved to Alpine in 1932 and remained there until their deaths. (Courtesy of Genoveva Ramírez Rodríguez.)

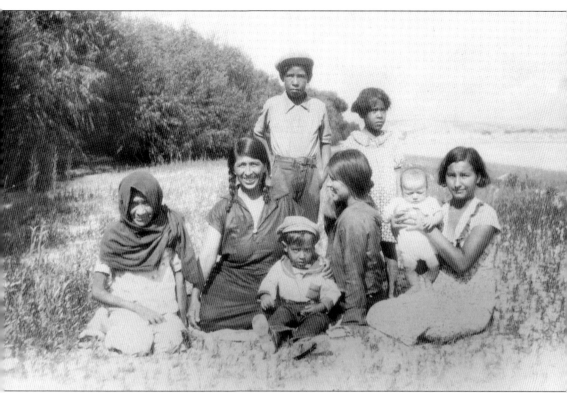

Pictured from left to right are (seated) Teta, Lucia Galindo Ramírez, Polo Dominguez, Placida Galindo Dominguez, baby Alvaro García, and Manuela García; (standing) Nicolas and Beto. Teta, whose last name is unknown, was from Juárez, but her family farmed across the river in Santa Elena. She was a storyteller and came to visit and entertain La Coyota families with many interesting stories. Lucia Ramírez's daughter Genoveva says La Coyota residents were always happy to see Teta. Like Teta, most women had a specialty. Lucia Galindo Ramírez was known as a fine seamstress. Here the ladies are posing on the banks of the Rio Grande. The river was not a border but a lifeline that joined communities and families and acted as a focal point for farming, ranching, and celebrations. Only in recent decades has the Rio Grande taken on the connotations of the border that it has today. (Courtesy of Genoveva Ramírez Rodríguez.)

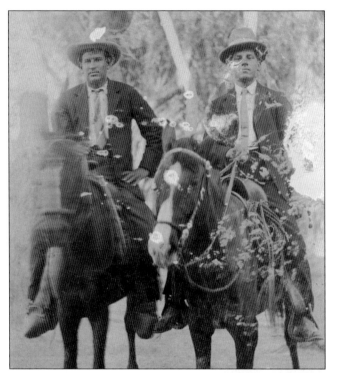

The sons of Wenceslado Ramírez, Eustaquio Ramírez (born around 1890) and Mariano Ramírez (born around 1895), immigrated from Mexico with their family in 1899. Eustaquio married Maria Luján, and they had two daughters, German and Maria Elena. Maria Luján Ramírez is buried in the La Coyota Cemetery (below). Mariano married Lucia Galindo Ramírez in 1918. Mariano and Lucia lived in La Coyota until 1944, when they moved to Alpine. They eventually moved to Artesia, New Mexico, where Mariano died in 1973 and Lucia died in 1992. (Left, courtesy of Genoveva Ramírez Rodríguez; below, photograph by Tom Alex.)

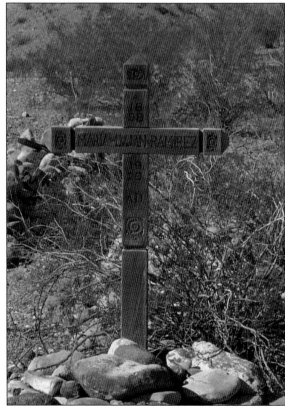

Life could be good, happy, and fulfilling in the Terlingua area, but it could also be hard and cruel. The small child in the center of this photograph is one of six unnamed Ramírez children who were stillborn or died soon after birth. A seventh baby, José, lived five days. All were buried in the La Coyota Cemetery, most by their father, Mariano. This 1929 photograph is part of a tradition to document the family and community and memorialize lost family members. In 1929, Mariano spent 250 days on the road freighting for La Harmonia Company, earning an amazing $1,100. However, that means that there is a good possibility that he was not present for the birth or death of this child. Pictured are, from left to right, (first row) Genoveva Ramírez (plaid shorts, sister to the baby), Rita Franco, Simona Chavarría, and Elvira García; (second row) Germana Ramírez, (sister to the baby), deceased child, and Juanita Franco; (third row) Carlota Estorga and German Luján Ramírez. (Courtesy of Genoveva Ramírez Rodríguez.)

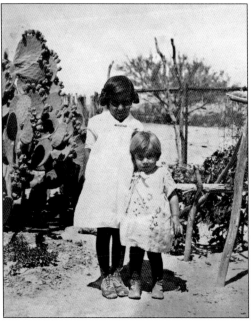

Lucia Galindo Ramírez (above) returned to visit La Coyota in 1989 at age 88. She recalled how much she loved living there. "Here we had no rent to pay, no utilities to break down. Life was hard, but simple, and we loved it." Lucia and Mariano lost seven of nine children (previous page). Only these two girls (left), Germana and Genoveva, survived beyond a few days. This photograph, taken in 1927, is of Germana, age seven, and Genoveva, age three. Genoveva remembers that the family washed their clothing in the Rio Grande and that there was a stove on the river that was used to heat water. She also fondly recalled carrying water in a bucket from the river to water the morning glories that she planted near the house. (Both courtesy of Genoveva Ramírez Rodríguez.)

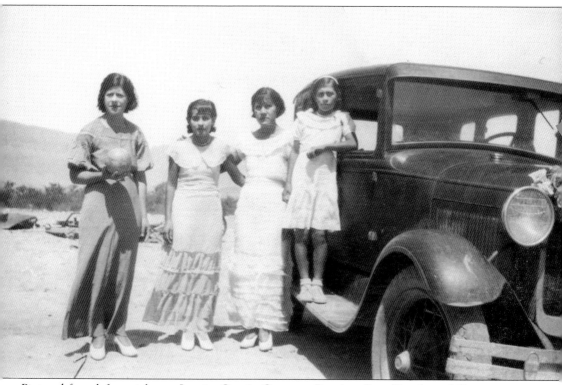

Pictured from left to right are Juanita García, Germana Ramírez, Beta García, and Genoveva
Ramírez. Almost all their clothing was handmade. Women often specialized in making dresses
or shirts or in crocheting. Other women specialized in cooking, making cheese, or gardening.
These beautiful party dresses were handmade by the girls' mothers, aunts, or the girls themselves.
(Courtesy of Genoveva Ramírez Rodríguez.)

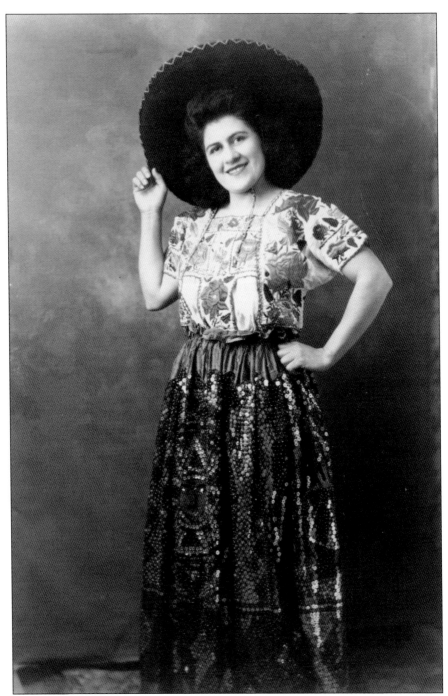

Genoveva Ramírez was born in La Coyota in January 1925 and lived there with her parents. She attended school in Castolon and eventually married a schoolmate, Alfonso Rodríguez. Genoveva is 89 years old at the date of this writing, and still retains a sharp mind with clear memories of her early life, her family, and her home at La Coyota. Genoveva is a major contributor of photographs and recollections presented in this publication. This photograph was taken in 1945, about a year before her marriage. (Courtesy of Genoveva Ramírez Rodríguez.)

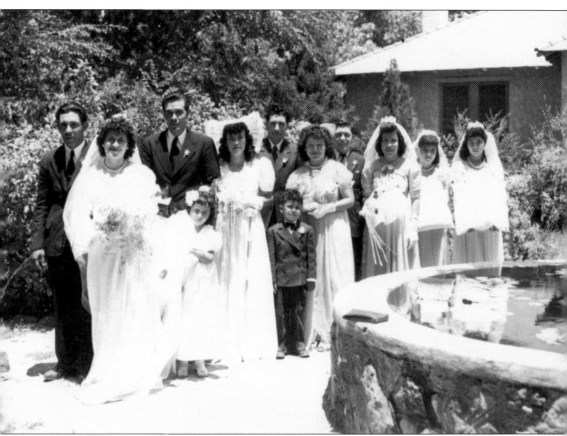

The wedding of Genoveva Ramírez to Alfonso Rodríguez on July 28, 1946, was well attended by family and friends. Genoveva and Alfonso grew up as classmates at the Castolon School. They eventually had five children, but the first and third died in childbirth. Their three surviving children are José Alfonso, Marta, and Hector. Genoveva and Alfonso were divorced in 1971 and lived in Odessa, Texas, in 2012. (Courtesy of Genoveva Ramírez Rodríguez.)

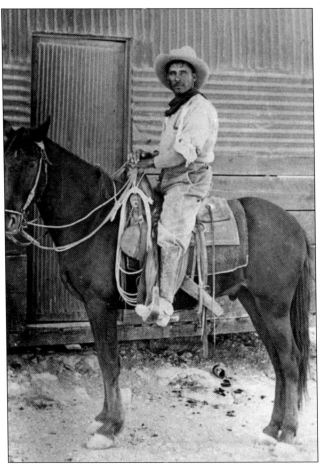

Félix Valenzuela served as constable for nine years. He was killed on duty in 1938 while he and Robert L. Cartledge, a justice of the peace, were attempting to stop Macario Hinojos and the López brothers for suspected contraband liquor. Accounts vary about a long-running animosity between Hinojos and Valenzuela that ended in Hinojos shooting Valenzuela twice, killing him. Another account that is unconfirmed was that Valenzuela had just sold a herd of cattle and was carrying a large sum of money, which was stolen. Regardless, Valenzuela was killed, and was buried the next day in the Terlingua Cemetery. Pictured below are, from left to right, O.C. Dow, H.O. Metcalf, Dewey Tom, and Creed Taylor with contraband liquor that was captured in 1926 (Left, courtesy of the Archives of the Big Bend; below, photograph by Frank Duncan, courtesy of Marfa Presidio County Museum.)

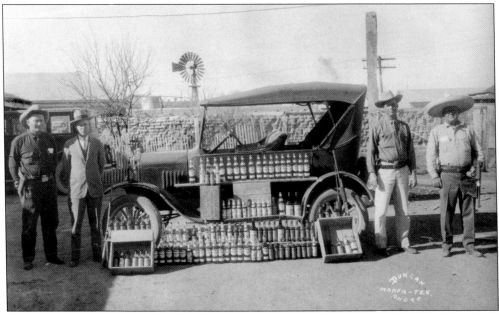

Félix Valenzuela (right), with unidentified friends, is standing in front of a "living" fence made from the stems of the ocotillo plant. Ocotillo fences are common in the Big Bend. When the freshly cut stems are set into the ground, they take root, and the fence continues to live and produce leaves and flowers after the summer rains. (Courtesy of Celestina Valenzuela.)

These are the fields of the Molinar Ranch located just a short distance from their neighbors, the Francos to the south and the Valenzuelas to the east. Simón Franco described their work, which included hauling freight, working in the mines, working livestock, and farming, as "breaking land, and harvesting water melons, and hay, and all that stuff that we sold to the mines. That's the way we made a living." Paz Molinar was born in Texas around 1879. He died in Terlingua in 1942 from bronchial pneumonia and is buried in the Terlingua Cemetery. The Molinar family settled on the west side of Terlingua Creek about a mile north of Antonio Franco. Paz owned three sections of land, where he farmed and raised cattle and goats. (Courtesy of the National Park Service.)

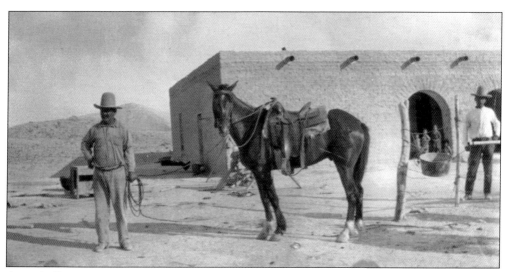

Antonio Franco (above), seen here with his horse 8-Bit, was a hard worker whose children worked just as hard. His two older sons, Benigno and Manuel, delivered freight when they were as young as 8 and 10 years old. Antonio's wife, Valentina, became crippled very early in their marriage, so the girls worked just as hard at home making asadero cheese, working the gardens, and completing all the other domestic duties. At right is Antonio's son Román Franco at age 10 in 1939 on his horse El Machito. Antonio Franco's brand was AF. (Both courtesy of Antonio Franco.)

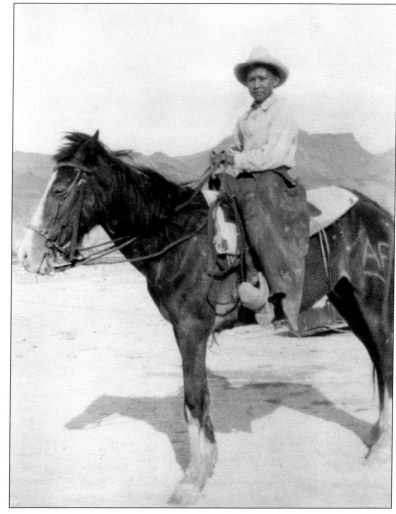

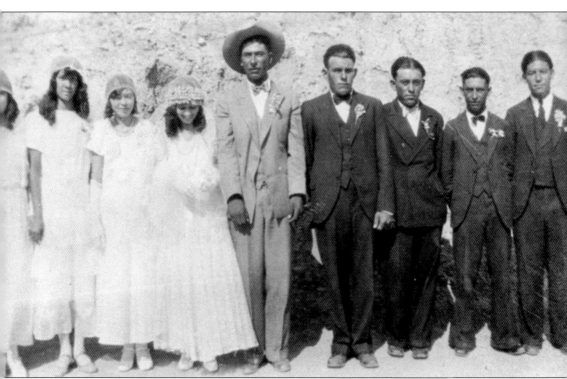

Marriages linked families into complex intertwinings of relationships. Pictured here is the wedding of Natividad García to Benigno Franco (fourth and fifth from left, respectively) in 1931. Their daughter, Maria Louisa, related that her father, Benigno, said that at night, sound carried far. Occasionally, galloping horses could be heard, and everybody would wonder who was coming. Benigno's father, Antonio, would get up and get his shotgun, and his mother would always say, "Antonio, stay in, do not go out." Antonio would call out in his loud voice, "¿Quién vive o muere? (Who lives or dies?)" The answer sometimes was "Primo Pablo (Cousin Pablo)," which would be Pablo Baiza. Antonio would say to his wife, "Get up and fix these folks something to eat." According to Maria Louisa, they always had a big pot of beans on the stove, and there was always other food for neighbors and relatives who stopped over. They were "primos." Benigno Franco would say that an old gringo told him, "Everyone is a 'primo' around here, and at night you hear the coyotes yipping, 'Primo, primo, primo!'" (Photograph courtesy of Museum of the Big Bend.)

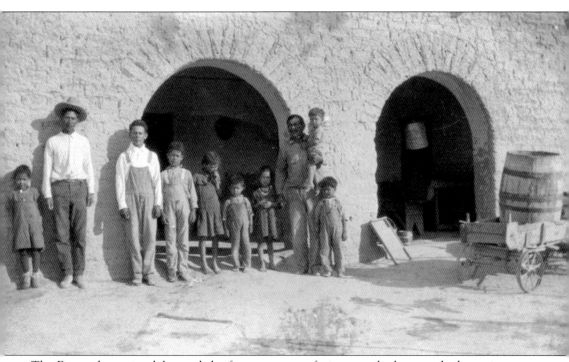

The Franco home is adobe, and the front entrance, facing east, had two arched openings, a feature unusual in the region. The rooms were behind this patio, which they called el zaguán. The Arabic word *zaguán* derives from Roman influence in Iberia, and its use in the Franco home reveals how architectural traditions migrated to the New World. In an old Latin household, the atrium originally was the mother's bedroom with a bed opposite the main entrance. This feature symbolized the sanctity of marriage. At the Franco home, the zaguán was the living and dining room. Once, Simón Franco did something that highly displeased his father, Antonio, who began to chase Simón to punish him. Simón's grandmother "Mama Rita" Ramírez was sitting in the zaguán crocheting. She wore long skirts, and when Simón came in, he ran under her skirt. She never said a word, just kept on crocheting. Antonio ran in and out the back door looking for Simón, but never did find him. (Courtesy of Antonio Franco and Maria Louisa Madrid.)

Shown here are Simón C. Franco (left) and Román Franco (right) in 1940. Simón worked alternating daytime and evening shifts, moving ore from as deep as the 350-foot level. They never worked below the 350-foot level because the shaft was flooded with water. For a time, Simón worked for a Mr. Haines, helping him pump water out of the shaft. At the 100-foot level of the main shaft in a tunnel to the east, water gushed out of the rocks, and workers could take a shower there. During World War II, Román worked for the machinists who ran the power generators for the Study Butte Mine. Román also worked for a time with the Civilian Conservation Corps in New Mexico. The Franco family was musically talented, and Simón said that when he moved to Alpine, he was surprised that the Hispanics and Anglos went to separate dances because everyone in the Study Butte area attended all the dances and weddings—and most of the dances were just "to dance," not for a special occasion. (Courtesy of Antonio Franco.)

The Francos loved music. All had good singing voices. Florentino "Tino" (pictured) was a good guitarist. A neighbor, Alec Smith, gave his violin to Tino's brother Simón. After she left Terlingua, their sister Alejandra became an accomplished pianist. They had a Victrola they would crank up to play records. Tino's brother Secundino had a girlfriend named Isabel, and they had the record *Las Isabeles*. He would play the record over and over and grab his sister, also named Isabel, to dance with him. She would kick and try to get away. Secundino tragically drowned in the Rio Grande in 1934 when he was 19. Afterward, they found the record still in the Victrola. Tino worked as rock mason with the Civilian Conservation Corps in the Chisos Basin (now in Big Bend National Park) and later served in the US Army during World War II. He was part of the 29th Infantry Division that was stationed in Germany. While he was there, he fought in the Battle of the Bulge. He was also a recipient of the Purple Heart. (Courtesy of Antonio Franco.)

Both the Franco and García families delivered milk and asadero cheese to local families. When this picture was taken in 1920, Gregorio García, driving the wagon, was 10 years old, and his sister Natividad, behind him, was 12. A few years later, when the Franco children were old enough to work, the Franco brothers and sisters would rise at about 4:00 a.m.; Juanita would prepare breakfast, and Manual would milk the cows. It was seven miles by wagon to the mine at "Chisos" (now Terlingua Ghostown), the Hispanic reference to the Chisos Mine at Terlingua. The families often traveled together on the deliveries to the area mining communities. (Courtesy of Louisa Franco Madrid.)

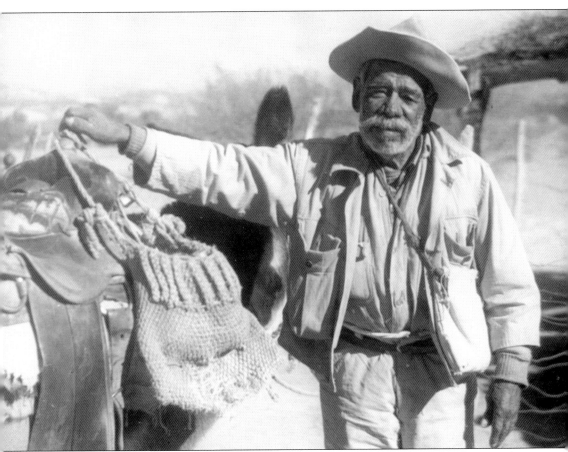

The legendary Gilberto Luna was of mixed Mexican and Indian blood, and several sources list his age at death as 108. He outlived several wives and had numerous children and grandchildren. Luna lived and farmed along Alamo Creek by capturing seasonal flows from this normally dry creek to irrigate a modest farm. The family grew their own food and managed a small herd of goats, and Luna provided a freighting service supporting the local economy. He delivered melons, vegetables, and cooked sotol, a traditional American Indian food, to families at Chisos. (Courtesy of the National Park Service.)

Federico Villalba came to the Big Bend with a vision as one of the first pioneers. His sense of honesty, morality, and sacrifice and his hard work helped weave his vision into the colorful fabric of Big Bend history. According to family history, he owned and developed many sections of land, which included much of what became mining claims. County records from 1902 confirm Federico's co-discovery with Tiburcio de la Rosa of cinnabar and co-ownership of the Study Butte mining claim. Mining mogul Howard Perry had a reputation for being less than above board on obtaining and managing his mining interests and started using some of Federico's land in Terlingua without purchasing the property. The contention over this and several other incidents led to the nickname for Perry as "El Perro." In 1907, Federico Villalba purchased 640 acres of land on the west side of Terlingua Creek and eventually acquired 9,600 acres there. The ruins of the house can be seen to the east from the Dolores García place. (Courtesy of Juan Manuel Casas.)

Federico Villalba eventually acquired a large tract of acreage at Burro Mesa. The large stone corral (above) built on Burro Mesa by Federico is a massive construction that still stands in testimony to the labors of this caballero. At right, Federico (right) and his son Jacobo (left) brand a calf. In the mid-1920s, they moved to a leased property along the Rio Grande. In March 2005, Herminia Esquivel Casas, daughter of Regina Villalba Esquivel and granddaughter of Federico, visited the ruins along the Rio Grande and identified them as Rancho Barras, the place she lived as a child. Other records confirm that Federico's Rancho Barras was very large, but its exact acreage is not known. (Above, photograph by Ray Scott, courtesy of Big Bend Resorts; right, courtesy of Juan Manuel Casas.)

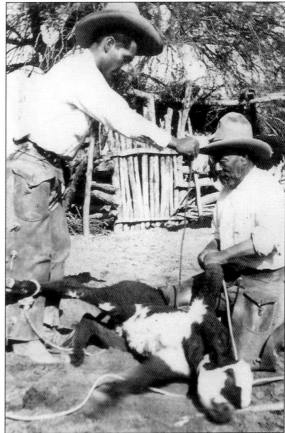

On the left are Felipe, son of Federico Villalba, and his son Ernesto (Cheto). Felipe left the Villaba family ranch and became a successful lawyer in El Paso. Below, standing in front of the Dolores García home, are Natividad García, Isabel Villalba (Felipe Villaba's wife), Simona García, and Ofelia Villalba (Felipe and Isabel's daughter). When Felipe and his family visited Terlingua, Isabel spent a lot of time visiting the García home. She was from El Paso, and married Felipe there. She would say that it was quite an experience when she first came to Terlingua with Felipe to see the men dressed as cowboys with guns, horses, and all the other accoutrements. Notice the beautiful flower garden around the house; flowers in the desert were an important aesthetic to most of the Terlingua families. (Both courtesy of Louisa Franco Madrid.)

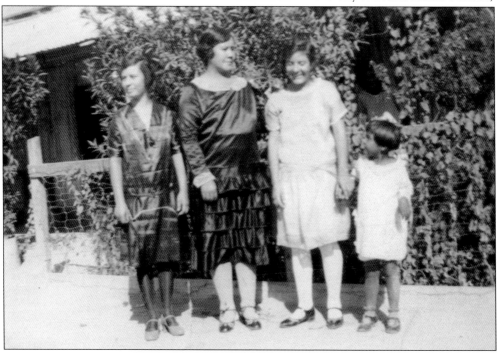

Julian Jiménez García (right) was born in 1865 and immigrated to the United States with his family around 1873, eventually settling in Terlingua sometime around 1900. Julian and his brother Dolores (below) worked as freighters and hauled mail between Terlingua and Alpine. By 1927, Julian was working as a salaried employee of the Chisos Mining Company, earning $54.25 per month. In September 1918, Julian purchased Section 254 of Block G-4 from Wayne Cartledge. This 640-acre tract lies between Study Butte and Terlingua and includes most of Cigar Mountain. This tract is still known today as the "García Section" and is still owned by Julian's descendants. Julian's brother Dolores García worked as a watchman for the mines in Study Butte for a while and at Chisos as a watchman. The Dolores García family was very respected in the community. (Both courtesy of Louisa Franco Madrid.)

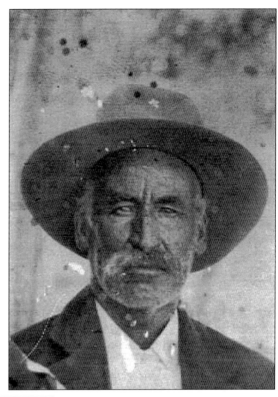

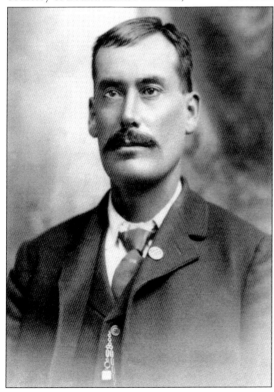

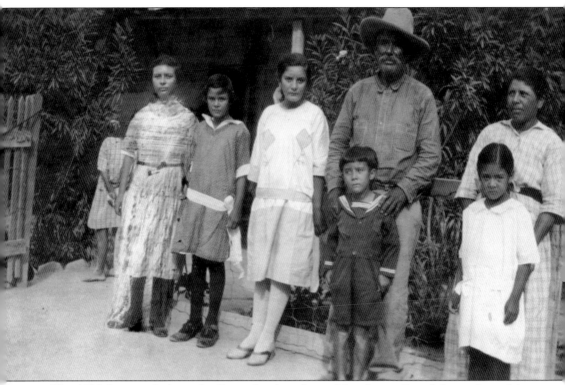

This 1926 photograph shows the García family in front of their house. From left to right are Maria (partially obscured), Natividad, Pepa (Josefa), Simona, Dolores, and Luisa. The two children in front are Acención and Trene. One day, Rosalia, Natividad, and Simona found some baby rabbits, and brought them home and made them into pets. They got attached to them. They were well fed and taken care of. Rosalia was the "bunny caretaker." Later, Papa Dolores noticed the rabbits and said, "Those rabbits are nice and plump and ready for a good meal." The girls could not believe what he was saying. They begged him not to do it, but he was determined to have them for dinner. So the girls took the rabbits far from the house and turned them loose. The rabbits kept following them, and they had to throw rocks at them to keep them from following them home. Rosalia was crying the whole time, but they saved them from Dolores's rabbit dinner. (Courtesy of Louisa Franco Madrid.)

Natividad García married Benigno Franco in 1931. One of her stories was about learning to drive, which she was afraid to do, and her brother Gregorio was not very patient. When she got home from school, Papa Dolores would tell her to go practice. Once they all got in the car, except Papa Dolores, the car took off fast. They were all screaming and frightened; she could not find the brake, so she drove onto a haystack. Papa Dolores was sitting on the porch watching. Josefa "Pepa" would say that that was the reason she had problems with her neck—she jumped out while the car was speeding out of control. Mama García had a dry sense of humor. She would look out into space and say, "I wonder what Papa would have done with all those dead bodies?" (Courtesy of Louisa Franco Madrid.)

This photograph is identified by the family as "Pepa y las vacas," or Pepa and the cows. Louisa Madrid relates a story about Pepa (Josefina) García that she calls "Enbrujaron a Romana (Witching Romana)." Pepa had a rag doll named Romana that she carried everywhere. Pepa was also Mama Luisa's favorite daughter. The other daughters were envious of all the attention she got from Mama Luisa. One day, her sisters Altagracia and Simona were scheming and said, "Why don't we stick pins on Romana and put her on the path where Pepa will go to the outhouse." So they did, and Pepa came along and saw Romana all stuck with pins and ran wildly screaming to Mama Luisa that *las brujas* (the witches) had bewitched Romana. When Mama Luisa saw Romana, she knew who the culprits were, and they paid dearly for their prank. Pepa was afraid of Romana after that. (Courtesy of Louisa Franco Madrid.)

In this photograph from 1936, Gregorio García stands at Study Butte Mine. Gregorio liked to scare his sisters and Mama Luisa by driving too fast. Once Gregorio was taking them to a dance, and a neighbor's white horse that was allowed to roam free was resting in the middle of the road. Gregorio did not see the horse in the dark, and he drove on top of it. Papa Dolores, who was on the porch with the younger children watching them leave, saw the car lights swaying back and forth and wondered what they were doing. The poor horse was trying to stand up, but the car was on top of him. Gregorio finally got the car off, and they drove off to the dance. Later, when he took the car to a mechanic, the mechanic said that it was very strange that some white hairs were tangled in the mechanisms. Gregorio just laughed and offered no explanation. The horse's owner told Papa Dolores that his horse "looked sad," did not feel well, and had a black oily spot on top of him. Again, no explanation was given. (Courtesy of Louisa Franco Madrid.)

At left is Miguel García, son of Dolores and Luisa García. He is about 17 years old in this photograph. Born in 1903, he died in a mining accident in Shafter, Texas, in 1938. Pictured below in 1929 are Micaela Hernández García and Natividad García. Micaela was born in Castolon (then known as Santa Helena), Texas, in 1905. The youngest child of Cipriano Hernández and Juana Silvas, she lived in Castolon until she was about 11, then at a site along Alamo Creek for a few years, and then in Terlingua de Abajo. At Terlingua de Abajo, she lived in an adobe below the hill where the village threshing circle was located. (Both courtesy of Louisa Franco Madrid.)

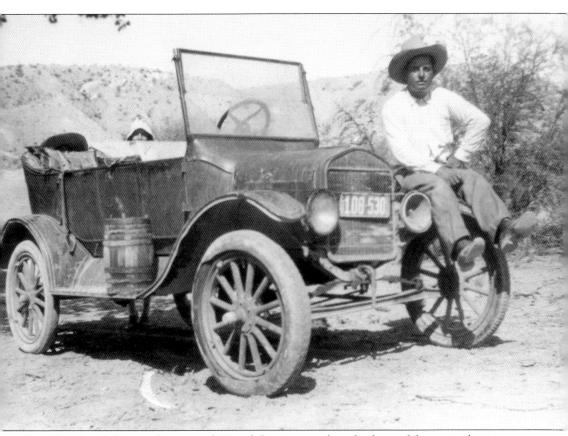

In 1922, Micaela Hernández married Miguel García, seated on the front of the car in this image. Micaela is hiding on the back of the car. (Courtesy of Louisa Franco Madrid.)

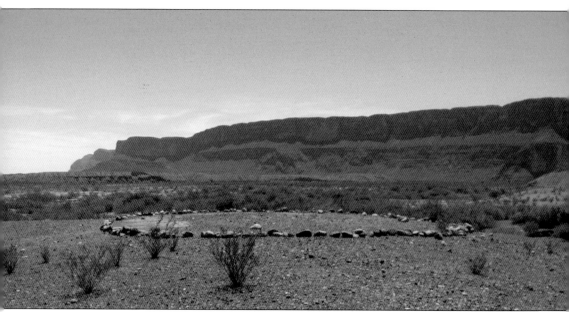

This is the threshing circle at Terlingua de Abajo. In 2003, when Micaela was interviewed at the age of nearly 98, she was in failing health but wanted to share her stories about her family and her life. She was very weak, and the interviewer had to pause frequently to let her rest. At one point in the interview, Micaela was asked what her favorite pastime was when she was young. She suddenly became alert and answered in a clear voice: "Oh, we danced! I loved to dance. And my favorite song was the Blue Waltz." "And where did you dance?" asked the interviewer. "Oh, in the big rock circle on top of the hill!" (Courtesy of Tom Alex.)

Three

COMMUNITY

To an outsider, the plethora of place names in the Terlingua area may at first be bewildering, but knowledge of the area's history explains exactly what place a local person may be referring to. Today, a large expanse of loose settlement goes collectively by the name Terlingua, but within this area, local names help differentiate (for people who live here) more precisely where the conversation pertains to. Lajitas, Ghostown, Villa de la Mina, 248, and Study Butte still define specific places that once saw concentrations of mining activity and settlement but today carry other connotations understood in a vernacular sense.

Someone driving into Study Butte and Terlingua for the first time is met with an eclectic mix of old and new. As the community came back to life without any kind of zoning restrictions, the full range of what can be called a house can be found here—stylish adobe and rock masonry, straw bale and wood frame, mobile homes and modular construction, and a smattering of what is best called quaint ticky-tacky. Aesthetics occasionally enter the formula, but generally, everyone spruces up their place with desert plants and gardens.

Tourism is the economic driver in Terlingua today. Big Bend National Park draws several hundred thousand people here each year. Big Bend Ranch likewise attracts people seeking more rustic conditions and fewer modern amenities. The demand for places to eat and sleep brought in a variety of motels and restaurants.

To "outsiders," identification with Terlingua revolves around certain locations or events that are familiar and comfortable. The corporate retreats at Lajitas, the chili cook-offs, and numerous other events bring people to Terlingua who otherwise might not find a sense of place here. The connection made is one that reveals responses from first-timers that "you either love it or hate it." And the locals commonly say, "You're not a local unless you spend the summers here." So, Terlingua continues to grow and change with the demands of the time. It is best dealt with as the fickle Texas weather is: if you don't like the way it is now, wait a bit and see what happens.

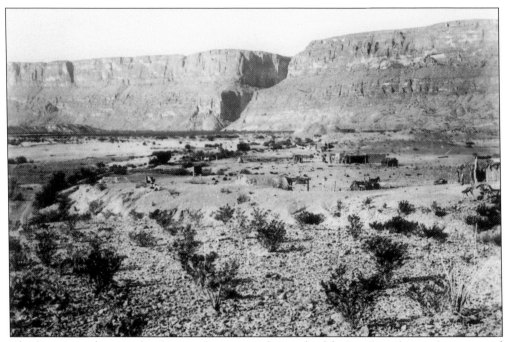

The farming settlement of Terlingua, about two miles north of the Rio Grande, was first occupied in the early 1880s. The community had around 50 residences on both sides of Terlingua Creek, and the community collectively farmed about 270 acres. This image shows the settlement along the west bank as it appeared in 1901; it was active until the 1940s. After the mining settlements claimed the name Terlingua, this place was called Terlingua de Abajo, or Lower Terlingua. Terlingua de Abajo has two cemeteries. The shrine pictured below is the Acosta/Martínez family cemetery, where Juan José Acosta (discoverer of cinnabar in the area) is buried. (Above, photograph courtesy of Southwest Collections/Special Collections Library, Texas Tech University, Lubbock, Texas, Collection Number NARA 22WB-30-3014; below, courtesy of National Park Service.)

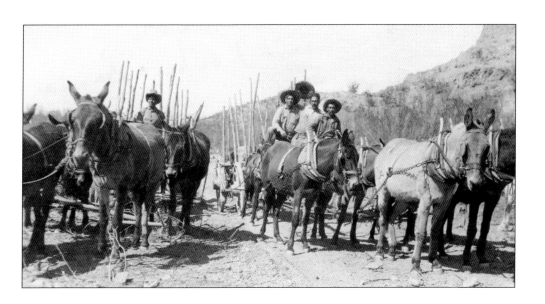

The villages of La Coyota and Terlingua de Abajo supplied the majority of the wood for the mining furnaces. Jesús García's sons Domingo and Tiburcio—both born in La Coyota—along with Pablo and Senon Chavarría, sons of Severiano Chavarría, were wood haulers from the La Coyota village. Severiano's son José also cut and hauled wood. Between September 1916 and July 1918, they sold nearly 97 cords of fuel wood to the Study Butte Mining Company for $703.10. In September and October 1917, José hauled over six tons of freight for the company for $66.21. José moved from La Coyota to Terlingua in the late 1920s but returned to La Coyota by 1930. (Above, courtesy of Louisa Franco Madrid; below, photograph by Glenn Burgess, courtesy of Jack Burgess.)

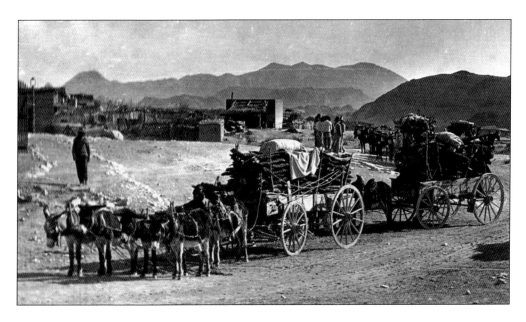

The brick factory at the ranch of Harry M. Dryden is a short distance north of Terlingua de Abajo. Dryden was contracted several times to produce bricks for construction of furnaces at mines in upper Terlingua. The 1904 report on the quicksilver industry by William B. Phillips mentioned that the Marfa and Mariposa Mine had two 10-ton Scott furnaces working and that the Big Bend Mining Company at Study Butte contracted for a 50-ton furnace. By 1907, Harry M. Dryden had produced over 500,000 bricks for these mines. (Photograph by Genna Mason, courtesy of the National Park Service.)

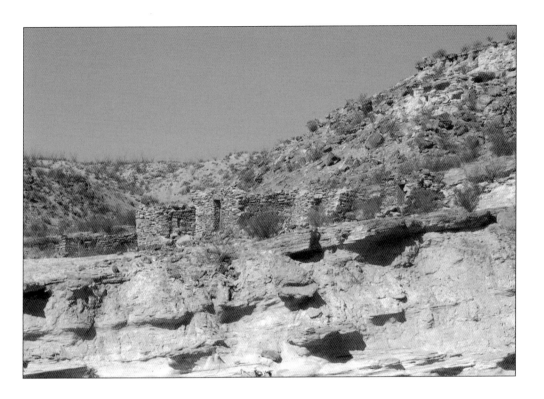

A few miles north of Terlingua de Abajo are the ruins of the Molinar and Franco homes. These massive stone and adobe ruins show the ravages of time since their abandonment. The Molinar place (above) still has large cylindrical columns that once supported the large porch. Some stone walls are almost three feet thick. The Franco adobe (below) once had two large arched openings leading into the zaguán. The arches have collapsed, but the front walls still stand almost eight feet high, a testimony of the masonry skills of that period. (Both photographs by Betty Alex.)

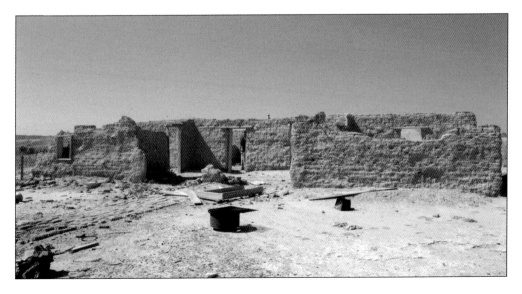

As miners arrived in Terlingua, they occupied any kind of temporary shelter available until they could build more substantial housing. The most commonly available construction materials were earth and stone, and most houses were combinations of rock and adobe masonry. The more substantial rock masonry buildings have survived much better than the adobe ones, which require annual maintenance to protect against the torrential monsoon rain and wind storms. Earthen material provides better insulation against the fickle weather changes, and visitors can still sense the simple comfort that these structures provided when walking from the hot summer sun into the cool recesses of one of these ruins. (Above, courtesy of Museum of the Big Bend; below, photograph by George Grant, courtesy of National Park Service)

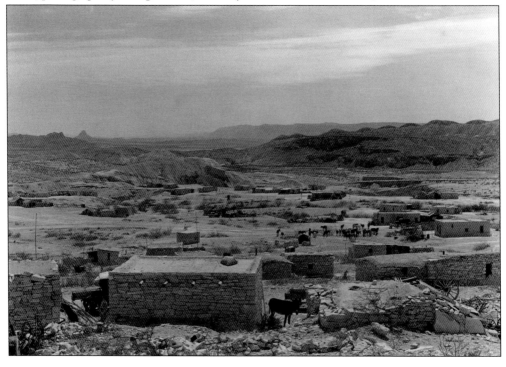

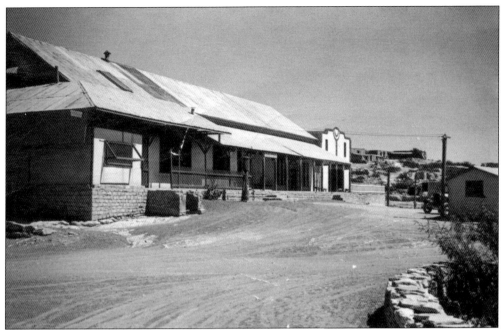

Hispanics working Howard Perry's Chisos Mine called the community pictured above "Chisos." There were weekly dances, a Catholic church, a movie theater (the building with a white façade at the far end), and an ice cream shop. Occasionally, a "supplier" came through selling *sotol* and tequila. The building to the left housed the company offices and the Chisos Store during the years of the mining boom and is now the Terlingua Trading Company. Below, the original Study Butte store was located below the Study Butte Mine. Both stores fell into ruin after the mines closed. This photograph was taken when Federico Villalba was the storekeeper. (Above, courtesy of María Zamarrón Bermúdez; below, courtesy of Juan Manuel Casas.)

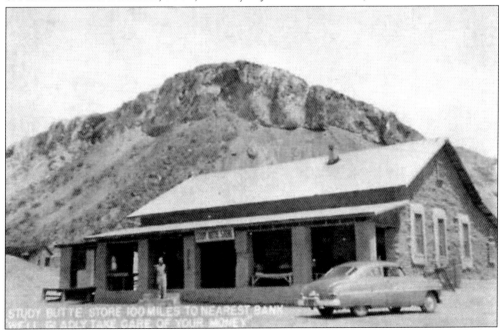

The original school at the Chisos Mine was in a "tent house," which had a canvas roof. It was eventually replaced with this wood frame building known to locals as the "Little Red School House." About 1930, Howard Perry replaced the building above with a larger building known as the "Perry School." Standing in front of the Perry School below are Trine and Maria García, children of Dolores García. (Above, courtesy of Celestina Valenzuela; below, courtesy of Maria Franco Madrid.)

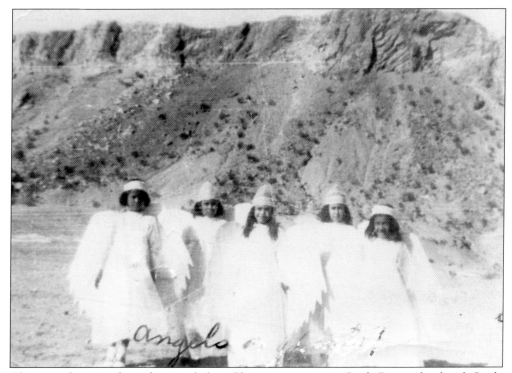

Above, students are dressed as angels for a Christmas pageant at Study Butte school with Study Butte in the background. Study Butte Mine is just out of view to the right. Today in Terlingua Ghostown, the old Perry School has fallen mostly to the ground. It is still possible to glimpse relics, such as the old Study Butte School (below), that are still attempting to stand in testimony of that long-ago time. (Above, courtesy of Louisa Franco Madrid; below, photograph by Tom Alex.)

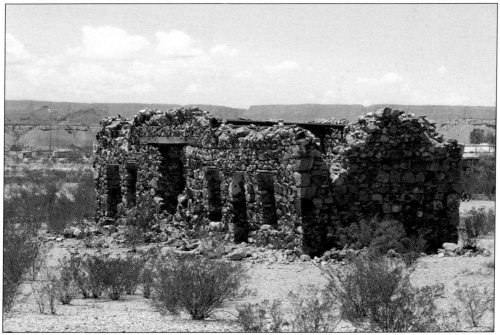

Pictured above are students at the Molinar School in about 1932. From left to right are (first row) two unidentified; (second row) Daniel Molinar, Rita Franco, two unidentified, Maria Molinar, four unidentified, Juanita Franco, and Luz Fuentes. Below, Terlingua Consolidated School District had around 100 students in kindergarten through 12th grade in 2014. The district relies heavily on county land taxes and, in recent years, has suffered financially. The school occasionally benefits from donations from the Chili Appreciation Society International Inc. (CASI), during its annual chili cook-off. The school has been able to ensure that graduates who intend to continue their education are awarded scholarships. Many students have gone on to graduate studies at major universities and colleges. (Above, photograph courtesy of Rita Franco Sanchez and Maria Louisa Franco Madrid; below, photograph by Tom Alex.)

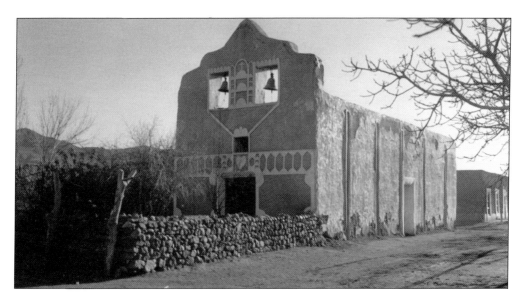

The church is a major influence in Hispanic culture and played a pivotal role in the lives of the Hispanic community of Terlingua. Many of the families who came to work in the mines passed through San Carlos, Chihuahua, and sought spiritual blessings in this modest church, pictured above as it appeared in 1936, during their journey. Church archives contain records of births, baptisms, weddings, and deaths and constitute a major genealogical database for Hispanic families. The Saint Agnes church in the Terlingua Ghostown, shown below, is under renovation in 2014 and is actively used. (Above, courtesy of the National Park Service; below, photograph by Betty Alex.)

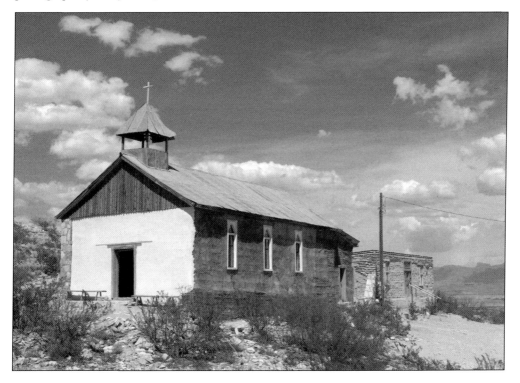

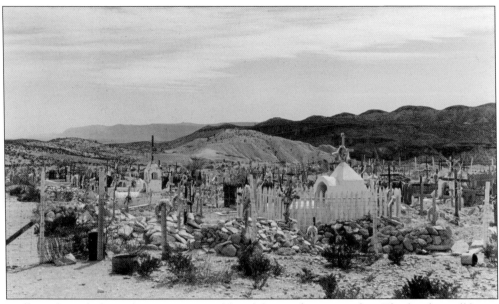

Walking through the Terlingua Cemetery (above), history lies at your feet. The families still living in the area return to their old homesteads and family cemeteries. On the Día de los Muertos (Day of the Dead), the community turns out to clean and decorate the cemetery and take part in a fiesta commemorating the lives of their ancestors. Below, the Dolores García crypt is located in El Camposanto del Arroyo, also known as the Mina de 248 Cemetery. Many of the Julian and Dolores García family members are buried here. This cemetery lies on private property near the 248 Mine and includes well over 100 graves, most of which no longer have identifying head markers. (Above, photograph by George Grant, courtesy of the National Park Service; below, photograph by Tom Alex.)

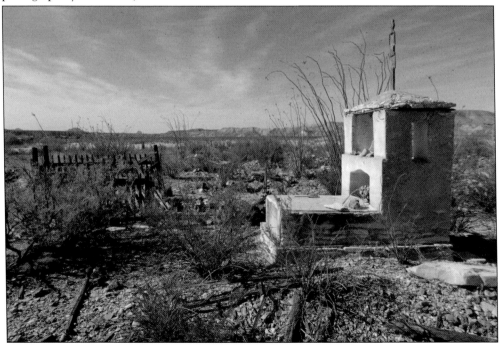

Father Brocardus is the most renowned cleric who served the Big Bend region during the first half of the 20th century. His circuit took him south from Fort Davis through the whole of what is now Brewster County. The numbers of marriages, baptisms, births, and deaths that he has attended are recorded by the church but remain to be counted. During the New Deal era of the 1930s, a move to establish a national park in the rugged Big Bend country led to the setting aside of over three quarters of a million acres centered on the Chisos Mountains, seen in the background in the image below. Economic collapse caused the abandonment of mining settlements, but a tourism economy arose in the 1970s. Terlingua transformed from a ghost town to a growing mecca for recreation. (Right, courtesy of the Archives of the Big Bend; below, photograph by Glenn Burgess, courtesy of Jack Burgess.)

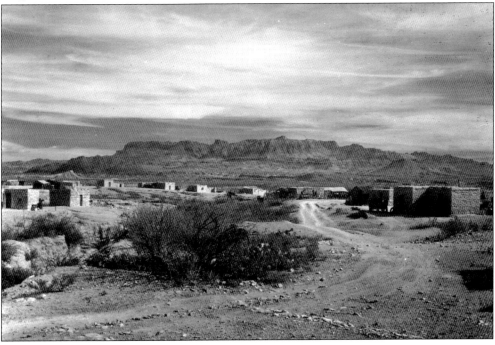

In the 1970s, the Rio Grande Guides Association began promoting river rafting and canoeing. Around 1975, Glen Pepper ran an outfitting business from Villa de la Mina, west of Terlingua Ghostown. About 1978, Far Flung Adventures set up its world headquarters in Terlingua Ghostown. Pictured from left to right are (first row) Jim Burr, Carolyn Burr, and Helena Harris; (second row) Mike Davidson (holding Nico Davidson), Sarah Bourbon, Ken Smith, Betty Moore, Pat Oxsheer, and Vickie and Steve Harris; (third row) Melissa Mills, Mark Mills (holding Wallace Mills), Rick Boretti, Richard Sharp, and Bill Blackstock. For several years, around a half dozen locally based river outfitters provided year-round service, but today, only three local outfitters remain. (Courtesy of Betty Moore.)

As business improved, boatmen and boatwomen came and left, but the business remained. Pictured above from left to right are (first row) Steve Smith, Betty Moore, Gail Rudder, and Laurie Kolbicz; (second row) Ruth Cisneros, Mike Davidson, Nico Davidson, unidentified, Tracy Blashill, Malcom MacRoberts, Pat Oxsheer, Ken Smith, Rick Boretti, Bill Green, Chris Mueller, Huck Gueske, and Gilbert Villegas; (third row) Charlie Fulcher, Pat Brown, Catfish Calloway, and Tommy Moore. During the summer monsoons and other occasional infusions of water into the Rio Grande, boating becomes a life-challenging event, as seen below. (Above, courtesy of Betty Moore; below, courtesy of John Morlock.)

"Wildman" John Morlock (left, background) was one of the founders of Far Flung Adventures. He went on to become the River District ranger in Big Bend National Park and then, further into his career with the National Park Service, superintendent of Fort Davis National Historic Site. Ken Smith (below) eventually became a contract mail carrier, delivering mail throughout the Terlingua area. (Both photographs courtesy of John Morlock.)

Far Flung Adventures also ran occasional river trips in Mexico. Two of the founders, pictured above, are Mike Davidson (left) and Steve Harris (right) with their Mexican guides while scouting the Rio Grande de Santiago in Jalisco for possible commercial river trips. Mike Davidson went on to become a major figure in developing tourism in Brewster County, and Steve Harris continued to run Far Flung in Taos, New Mexico, but also became an activist in protecting and preserving wild rivers. Below are three Far Flung boatmen in the Lower Canyons in 2006. From left to right, they are Tommy Conners, Steve Belardo (in the kayak), unidentified. (Both courtesy of John Morlock.)

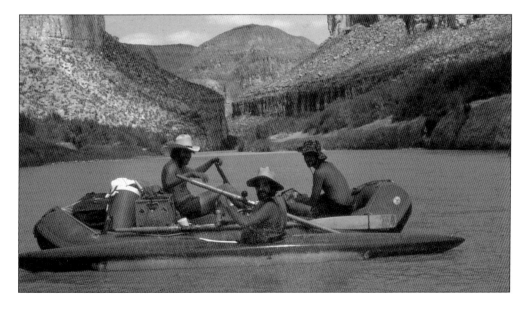

Today, Far Flung Adventures operates both in Terlingua and in Taos, New Mexico, providing recreational experiences for thousands of people. The Terlingua office is located west of the intersection of State Highways 118 and 170, and the company has expanded to include jeep tours and ATV tours as well as river boating trips. In recent years, the company has built cabins adjacent to the office and provides lodging as an additional service. (Above, photograph by Tom Alex; below, courtesy of Far Flung Outdoor Center.)

Above, Far Flung Outdoor Center contends with the diminished flow of water in the Rio Grande by providing a variety of outdoor activities that include river boating, guided hikes, and vehicle tours that are strictly kept on paved and dirt roads. Below, for a uniquely rewarding way to experience the grandeur of the Big Bend, Rio Aviation offers aerial tours over Big Bend National Park, Big Bend State Park, and areas between. Owner and pilot Marcos Paredes was a river guide with local outfitters and worked as the River District ranger in Big Bend National Park prior to his retirement. In 2010, Marcos started up his Rio Aviation business, which operates at the Terlingua airstrip between Terlingua and Study Butte. (Above, photograph by David Kozlowski, courtesy of Far Flung Outdoor Center; below, courtesy of Marcos Paredes and Rio Aviation.)

Big Bend River Tours is another recreational services company. It was started in 1985 by Beth García, who continued management until 2000, when she sold the company to Jan Forte. During Beth's heyday, the company was grossing nearly $1 million a year with 43 guides during the spring. Beth's recollections of her period of management were of "a passionate love-hate relationship. I loved promoting the Big Bend area and helping people have fun and see the magic that lives in those canyons and that scenery. Even the more 'mundane' open country of the half-day trip is stunning. It always left people inspired and happy. It's hard to have a bad day at work when you focus on the majesty of the Big Bend Country." The company also offers guided hiking and vehicle tours along with river recreation. (Both photographs by Tom Alex.)

Desert Sports was originally founded in the late 1980s by Mark Mills, who operated the business in Lajitas. Like many boating businesses that rely on the fickle changes in the Rio Grande and fluctuations of tourist economics, the business moved, eventually ending up in Terlingua, across highway 170 from the Terlingua Store. Desert Sports was incorporated in 1996 by Jim Carrico, former superintendent of Big Bend National Park, and Mike Long, longtime river guide and mountain bike enthusiast. The company, like all the river outfitters, still manages through bouts of drought, economic recessions, and border closures. As the Rio Grande is depleted of its water and river trips become temporarily untenable, outfitters like Desert Sports provide a variety of backcountry experiences. (Photograph by Crystal Allbright, courtesy of Desert Sports.)

The boatman in the photograph above is Mike Long, who is taking John Leroy and Marie Leroy through Colorado Canyon, the only igneous rock canyon in the Big Bend. The various outfitters provide trips through the spectacular canyons of the Big Bend, and others, such as Desert Sports, provide guided tours on mountain bikes, as seen below. Big Bend Ranch State Park and the Lajitas Resort allow mountain biking on over 200 miles of trails and two-track dirt roads. (Both photographs by Crystal Allbright, courtesy of Desert Sports.)

"**Chili eaters is some of your chosen people, Lord. We don't know why You so doggon good to us...**"*

*THE UNKNOWN RANGE COOK

F R A N K X. T O L B E R T

The 18th ANNUAL
ORIGINAL
Terlingua International
Frank X. Tolbert □ Wick Fowler

BEHIND THE STORE MEMORIAL CHAMPIONSHIP CHILI COOKOFF ON NOVEMBER 3, 1984

Some people associate Terlingua with the annual chili cook-off. By one account, in 1967, Frank X. Tolbert, who had a knack for tongue-in-cheek humor, and Wick Fowler held the first Terlingua competitive chili fest, somewhat in jest. As beans and green chilies showed up in the concoctions, objections from competitors laid down the rules that only red peppers, coarsely ground meat and a few other ingredients (*never* beans!) were allowed. Over the years, part of the group sought to make the cook-off more business-like to raise funds from corporate sponsors. This faction took up the name Chili Appreciation Society International Inc. (CASI). The Tolbert-Fowler group wanted to keep the cook-off more family-like and less commercial. So today, CASI operates at its own location west of the Ghostown, and the Tolbert-Fowler group holds its event behind the Terlingua store, east of the Ghostown. The popularity of both events spurred similar events elsewhere in the country and in Europe, and a popular restaurant chain was founded on chili dishes. (Courtesy of CASI.)

During chili cook-off week, the area population grows by about 10,000 souls, all intent on kicking up their heels. The early years saw a high consumption rate of spirits and overindulgence in revelry, which, to many locals, was both a source of diversion and revulsion. The image above was taken when the chili cook-off was held at the Villa de la Mina, the old Colquitt-Tigner mine property, which was then owned by Glenn Pepper. On February 17, 1990, ground breaking began at what was to become Rancho CASI de los Chisos (below), just east of California Hill. This location would be identified for many as the site for the "Terlingua Chili Cook-off" that became the home of the annual Chili Appreciation Society International Inc. event. (Above, courtesy of John Alexander; below, courtesy of CASI.)

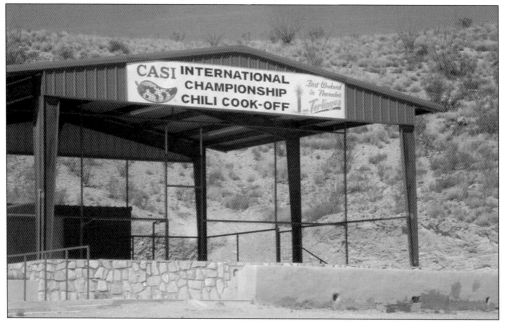

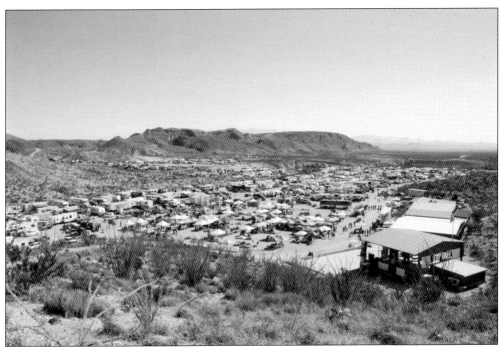

The annual CASI event is one that the locals tolerate and the participants relish. Along with the sudden boost to the local economy come a dozen or more deputies, highway patrolmen, and increased emergency medical aid to deal with heat stroke, dehydration, and overconsumption. Over the years, the amount of overindulgence has decreased, and these events have generated substantial revenue, supporting growth of the Terlingua School, fire and emergency medical services, and local businesses. (Both photographs by Jennifer Sherfield, courtesy of CASI.)

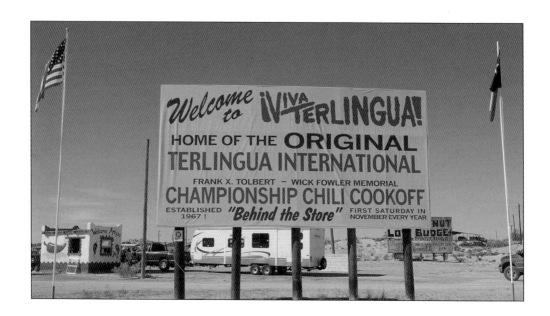

The Frank X. Tolbert–Wick Fowler Chili Cook-off is held each year behind the Terlingua store on Highway 170. This event does not generate as much revenue as the CASI event, but the smaller crowd and generally more laid-back atmosphere is loved by many chili aficionados. Competition is held for not only chili but also a variety of foods. And beverages of various brands are consumed in large quantities as well. (Both photographs by Melanie Levin.)

Each event is judged by specific rules that are strictly adhered to by participants, and judges are instructed in proper procedures. Although the cook-off is generally a very informal event, the judging is carried out with serious attention to procedures. There is still plenty of room for fun in the process, though. (Both photographs by Melanie Levin.)

During and after the formal judging, the attendees treat these events like a huge family reunion, and many of the original cook-off attendees make this the highlight event of the year. Both the CASI and Tolbert-Fowler cook-offs generate charitable fundraising, donating to the local school and Terlingua Fire and Emergency Services (below). The event draws several thousand people to Terlingua each year who also bring in much revenue for area businesses. The Behind the Store Cook-Off has a smaller crowd, but a family atmosphere pervades the event. The cook-off is celebrated with flair and gusto. (Left, photograph by Melanie Levin; below, photograph by Betty Alex.)

Many locals avoid the chili cook-off crowds and, in response, have created two "locals-only" events, the Cookie Chilloff and the Black-eyed Pea Off. The January 1, 2010, Black-eyed Pea Off (above) brought out many on a cold day to celebrate the new year with friends and neighbors. In the image below, event promoter Pam Ware, standing at left center, and Terlingua justice of the peace Jim Burr, seated at right, are overseeing the raffle on the Chisos Mining Company porch. The Terlingua Trading Company entrance is in the background. (Both photographs by Tom Alex.)

Carlos Mendoza (above, center), with family and friends, is a longtime resident of the area. He is just one of the many Hispanic/Latino people within the community of Terlingua today who contribute much in labor and volunteer services. Below at left is Carolyn Burr, wife of Jim Burr and owner of El Centro in Study Butte. At far right is David Long, supervisor for the Barton Warnock Center in Big Bend Ranch State Park in Lajitas. Long is talking with Jim Carrico, who stands in the center. Carrico is a retired superintendent from Big Bend National Park, who served as West Texas regional director for Texas Parks and Wildlife following his retirement from the National Park Service. Such people compose the community today. (Both photographs by Tom Alex.)

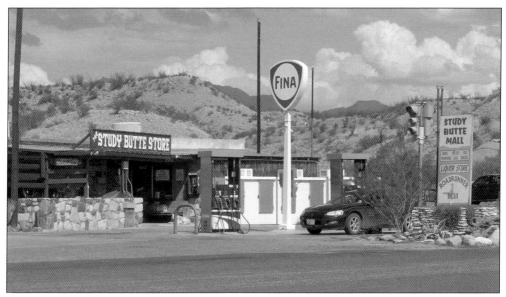

In the 1970s, the Study Butte Porch Society included boatmen, desert rats, a physicist, assorted societal dropouts, and escapees from urbanity who congregated on the porch of Study Butte Store (above), where there was ample shade and a supply of cold beer. Their philosophical and metaphysical discussions on the Study Butte porch could fill volumes of self-help books and social commentaries. In the late 1970s, Gil Felts built La Kiva Bar and Grill (below), which became the hangout of choice on hot days and nights. Sadly, the owners of both businesses have passed away, and locals are waiting hopefully to see if they reopen someday. The old philosophical mecca has relocated to the porch in the Terlingua Ghostown. (Above, photograph by Tom Alex; below, photograph by Betty Alex.)

In earlier years, the building above was a favorite eating establishment that housed Uncle Joe's Burgers, followed by Aunt Roberta's Café, Boatman's Bar and Grill, and Ms. Tracie's Café. Today, El Centro operates in this building as H2O to Go, a bottled water service, and also provides an interesting array of goods in its collectibles shop. In the 1970s, rancher and constable Billy Pat McKinney owned the gas station below and hired Dale Hall to operate it. Billy Pat, who served as a pilot in the border patrol and later was a private pilot, is known to have landed his plane on the highway and taxied in to gas it up. Later, Ken Barnes displayed his dinosaur fossil collection here. Today, Many Stones sells an eclectic mix of rocks, jewelry, lapidary supplies, cactuses, and other gift items. (Both photographs by Tom Alex.)

Shown above in the 1960s are renowned geologist and first superintendent of Big Bend National Park, Dr. Ross Maxwell, and Ollie Fulcher Henson at the Terlingua Post Office. The post office has moved several times since the mining days and today occupies the building below. (Above, Ross Maxwell Collection, courtesy of the National Park Service; below, photograph by Betty Alex.)

The building above has also seen multiple occupants. During the 1980s, it housed the Terlingua Post Office until the new red brick post office was built (preceding page). It was for a short time a woodworking shop and is now the Rio Bravo Mexican Restaurant. The restaurant is run by local Hispanic families who cook in traditional northern Chihuahuan style and put together some excellent meals. Next door to the current post office is another popular Mexican restaurant, the Chili Pepper Café (below). This is another of the newer businesses that opened in Study Butte during the population growth that has occurred over the last two decades. (Above, photograph by Tom Alex; below, photograph by Betty Alex.)

In the 1960s, travelers on highway 170 saw a sign directing them to the Lajitas Trading Post, "the last gasoline stop for 60 miles." The trading post operated for over 100 years and was the closest grocery and dry goods store for residents on both sides of the border. Prior to September 11, 2001, people could easily move back and forth across the border at the shallow crossing on the Rio Grande between Lajitas and Paso Lajitas, Chihuahua. For Mexican citizens in Paso Lajitas, it was easier to get groceries and mail here than to drive several hours to San Carlos or Ojinaga, Chihuahua. (Courtesy of Lajitas Resort.)

Lajitas experienced a dramatic alteration in the late 1970s when Walter Mischer constructed a quaint western-style boardwalk and hotel (at right) dominated by an authentic saloon, which is popular with the locals. His nine-hole golf course in the Rio Grande floodplain, however, was frequently flooded. Mischer sold out to entrepreneur Steve Smith, who poured millions into the resort, building newer lodging (at left), condominiums, and an equestrian facility, and expanding the golf course to 18 holes. Lajitas Trading Post, a thriving business prior to Smith's acquisition, was forced to close due to financial problems. (Photograph by Betty Alex.)

Finances finally forced Steve Smith to sell out to the highest bidder, who, shortly after acquiring the property, watched the golf course disappear under the 2008 Rio Grande flood. (Photograph by Betty Alex.)

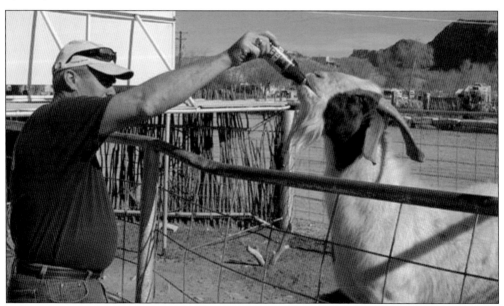

A legendary member of the Lajitas community was Clay Henry, the "Beer Drinking Goat" who was also elected mayor each year, mostly by default. Clay Henry passed away and his mounted remains, as of the writing of this book, are on display at the Starlight Theatre in Terlingua Ghostown. (Courtesy of Lajitas Resort.)

Rick Page was the last person operating the Lajitas Trading Post before it was purchased by entrepreneur Steve Smith. Rick purchased the business from Roger Gibson in 1997 and operated the store until 2001. In 2009, Rick opened the Cottonwood Store in Study Butte. (Photograph by Tom Alex.)

The original Hotel Chisos in Terlingua was nothing more than a wood plank floor covered by a tent. It was eventually replaced by this more substantial wood-frame building with a tin roof. The ruins of this building now serve as a community crisis center and general meeting area. (Courtesy of Maria Zamarrón Bermúdez.)

The Chisos Mining Company Motel was built in 1985 in Study Butte and is one of several motel accommodations in the area providing lodging, cabins, and an interesting curio shop. (Photograph by Tom Alex.)

In the Ghostown, just west of the old Chisos Hotel is another building that was used generally as lodging for most of its history. It was in poor condition when Far Flung Adventures took up residence there. Recently, the building has been renovated and provides lodging under the name of the Holiday Hotel. (Photograph by Betty Alex.)

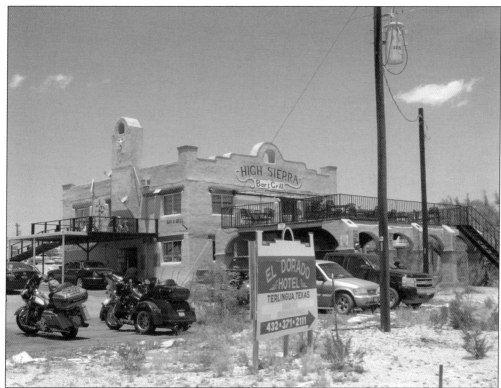

At the entrance road to the Ghostown is another facility that arose during the past decade or so of population increase: the El Dorado Hotel and High Sierra Bar and Grill (above). This establishment, like the Starlight Theatre in the heart of the Ghostown, sponsors a variety of musical entertainment as well as food and beverages. The Big Bend Motor Inn (below), currently operated by Big Bend Resorts, provides motel accommodations, RV and tent camping, a café, and a gas station. (Above, courtesy of Maria Zamarrón Bermúdez; below, photograph by Betty Alex.)

Located near the Big Bend Motor inn, Big Bend Stables (above) provides local horseback rides. The growth of Terlingua in the last two decades began with people sprucing up the old ruins in what was the Mexican section of the old Ghostown (below) as well as in abandoned sites such as the old 248 Mine. After the turn of the 21st century, development of the area increased exponentially and encroached on the Terlingua Historic District. In the early years, such modifications were aesthetically compatible. The more recent development provides a stark contrast to the older architecture, lacking historic sensitivity to the Terlingua National Register Historic District, and longtime locals have expressed displeasure about the slowly encroaching "non-historic" and "incompatible" development around the Ghostown. (Both photographs by Tom Alex.)

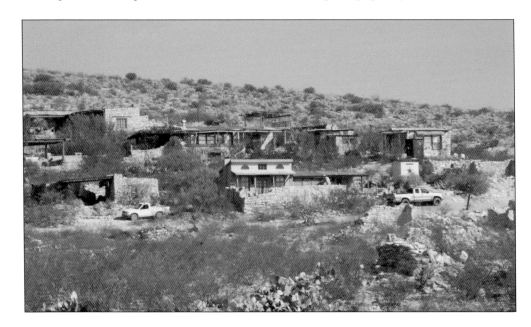

During the hot summer when tourists seek a shady spot, the Ghostown will see a few vehicles moving toward local watering holes like the Starlight Theatre (above), where crowds mingle on the porch. Musicians flock to the venue of Terlingua. Terlingua Trading Company occupies the old Chisos Mine offices, where people can find the second-best bookstore in Brewster County. The bookstore caters to the eclectic mix of locals but provides an array of literature appealing to the general visitor and intellectual alike. Just a few yards away (below) is another secret getaway: La Posada Milagro, where tastefully renovated historic ruins make comfortable cottages that are a welcome respite from the modern amenities—though you can also stay in touch with them, if you absolutely must. (Both photographs by Tom Alex.)

The authors, Robert "Bob" Wirt (at left) and Tom Alex (at right), enjoy an afternoon on the Ghostown porch. Bob and his wife, Scarlett, worked as volunteers at Big Bend National Park, and Scarlett was kind enough to allow Bob to come west from Maryland and spend several months each year delving into archives, church records, and county court records to build an extensive database of family history. Bob's website, Life Before the Ruins, is still a work in progress. His passing on January 12, 2013, was a shock to many and a loss to the heritage of Terlingua and the Big Bend region. This closing image is dedicated to Bob, an incredible history researcher, respected father, and beloved husband, as well as a close friend. He touched many people while he was with us, and he is sorely missed by many. (Photograph by Betty Alex.)

BIBLIOGRAPHY

Burcham, W.D. "Quicksilver in Terlingua, Texas." *Engineering and Mining Journal* 103, January 13, 1917: 97.

———. "Report on the Mariscal Mercury Mine." Unpublished manuscript on file, Big Bend National Park, Texas, August 24, 1936.

Hawley, C.A. *Life Along the Border.* Spokane, WA: Shaw & Borden Co., 1955.

Madison, Virginia. *The Big Bend Country of Texas.* Albuquerque, NM: University of New Mexico Press, 1955.

Phillips, William B. "Condition of the Quicksilver Industry in Brewster County, Texas." *Engineering and Mining Journal,* October 6, 1904: 376–79.

———. "Condition of the Quicksilver Industry in Brewster County, Texas." *Engineering and Mining Journal,* November 20, 1909: 1,022–24.

Ragsdale, Kenneth Baxter. *Quicksilver: Terlingua and the Chisos Mining Company.* College Station, TX: Texas A&M Press, 1976.

Schuette, C.N. *Quicksilver, Bureau of Mines Bulletin 335.* Washington, DC: US Department of Commerce, 1931.

Tolbert, Frank X. *A Bowl of Red.* College Station, TX: Texas A&M University Press, 2002.

Walthall, Harris. Harris Walthall Collection. Resources Management History File. Big Bend National Park.

www.abowlofred.com

www.chili.org

Yates, Robert G., and George A. Thompson. *Geology and Quicksilver Deposits of the Terlingua Mining District.* Washington, DC: Government Printing Office, 1959.

———. *The Mariposa Mine, Terlingua Quicksilver District, Brewster County, Texas.* USGS Open-File Report, 1944: 44–75.

———. Geologic maps and sections, Study Butte Mine, Terlingua quicksilver district, Brewster County, Texas. USGS Open-File Report, 1966: 66–156.

DISCOVER THOUSANDS OF LOCAL HISTORY BOOKS FEATURING MILLIONS OF VINTAGE IMAGES

Arcadia Publishing, the leading local history publisher in the United States, is committed to making history accessible and meaningful through publishing books that celebrate and preserve the heritage of America's people and places.

Find more books like this at
www.arcadiapublishing.com

Search for your hometown history, your old stomping grounds, and even your favorite sports team.